What people are saying about

Scene Change

T0355580

Alan Harrison's *Scene Change* is not only a must-read for arts administrators and fundraisers—it's also a must-read for donors, board members, and anyone interested in the performing arts. The book is serious and funny at the same time, and Alan's revelations about his career in theater, starting with his gig as a "flyerer" on Broadway, show his tenacity as well as his ability to see the business side (warts and all) of arts organizations. As a donor to the arts myself, I hope that anyone who supports the performing arts will read this and take note. It's time for a change!

Lisa Z. Greer, Author, *Philanthropy Revolution*

With passion and humor, Alan Harrison challenges virtually every assumption under which nonprofit arts organizations have operated for the last 50 years. But while he challenges sacred cows left and right, don't be fooled into thinking he is a cynic because, underneath it all, this fervent manifesto reveals that he is a cockeyed optimist with a breathtaking vision of how arts organizations should operate over the next 50 years.

Robert Wildman, Associate Professor and Director, Arts Administration Programs, Winthrop University

Alan Harrison doesn't speak softly. He's not exactly subtle. And he seems to revel in taking victory laps when he points out business-as-usual behavior that is seriously broken. But his shoot-from-the-hip observations about what's ailing the nonprofit arts world and what to do about it are incisive, insightful, and grounded in keen observation of human behavior. Most of all, he wants to reset the paradigm in which

arts institutions ply their craft. In a world awash with shiny objects vying for our attention, he suggests that simply making good art isn't enough; we also have to make impact by meaning something to the communities we serve. And he is full of ideas about how to do it. Harrison wants to cut away the clutter, the busy work that masquerades for accomplishment, and get arts leaders laser-focused on accomplishing things that matter. It's time, Harrison believes, for a little straight talk on culture after the pandemic, on racial equity, on how to identify and get your community motivated to support you. He's loud. He's blunt. And he doesn't seem to care if he offends. You may disagree with him as he makes you mad. That's okay; he's quite happy to be the provocateur. Love him or hate him, he speaks a whole lot of common sense.

Douglas McLennan, Editor, *ArtsJournal*

Scene Change

Why Today's Nonprofit Arts
Organizations Have to Stop Producing
Art and Start Producing Impact

Scene Change

Why Today's Nonprofit Arts Organizations Have to Stop Producing Art and Start Producing Impact

Alan Harrison

Edited by Sherry Ward

CHANGEMAKERS
BOOKS

Winchester, UK
Washington, USA

JOHN HUNT PUBLISHING

First published by Changemakers Books, 2024
Changemakers Books is an imprint of John Hunt Publishing Ltd., No. 3 East Street,
Alresford, Hampshire SO24 9EE, UK
office@jhpbooks.com
www.johnhuntpublishing.com
www.changemakers-books.com

For distributor details and how to order please visit the 'Ordering' section on our website.

ISBN: 978 1 80341 446 1
978 1 80341 447 8 (ebook)
Library of Congress Control Number: 2022948105

A CIP catalogue record for this book is available from the British Library.

Design: Lapiz Digital Services

UK: Printed and bound by CPI Group (UK) Ltd, Croydon, CR0 4YY
Printed in North America by CPI GPS partners

We operate a distinctive and ethical publishing philosophy in
all areas of our business, from our global network of authors to
production and worldwide distribution.

Contents

I've broken nine commandments.
I don't think I've killed anyone. But there's still time.
Clearly, I am no saint. Remember that as you read this book.
It was not written by someone giving you a Sermon on the Mount.
If you are leading an arts organization, just know that this was written by someone who experienced the same sort of anxiety that you are facing now. And succeeded.
Mostly.

Preface

I believe it's time to challenge the "givens" in the nonprofit arts sector.

The arts constitute the only portion of the nonprofit sector where the donor is also the user. Donors donate so that donors may attend. The "given" that the nonprofit arts industry is a playground of arts creation for those with the capital to fund it has doomed it swiftly down a whirlpool of irrelevance to become a target for paint-throwing activists railing against the uncaring elite.

The purpose of nonprofit arts organizations is not about the telling of stories or the production of art, but the production of impact using the arts as tools. The "given" that has led the sector to a deserved destruction is its vainglorious depiction of art as a goal, which has led to predictable ventures into cataclysmically elitist behavior.

Like every other nonprofit organization, they must measure their impact, not by transactional relationships of ticket buying, but by the number of people who are better off in the most fundamental societal ways because of the work.

Some artists may choose to believe that this book is not for them; it is those artists for whom this book was entirely meant. They may disagree and argue to keep their nonsensical visions of "art for art's sake" alive. Great. Engagement is the first step toward understanding what your community needs.

Do you remember a 1972 disaster movie called *The Poseidon Adventure*?

An enormous, obsolete cruise ship gets flipped upside-down by a tidal wave. A small, courageous, but ordinary band of passengers recognizes that to escape, they have to travel

upward, toward the hull. A priest (Gene Hackman) leads them, both physically and spiritually.

There was a scene in the movie early on where our plucky gang of travelers came across a large group of passengers led by crew members downwards, toward what they believed was the only exit from the ship, the deck. The crew members only knew one way to behave in this situation, and that was to get the passengers to the upper decks, which were submerged under hundreds of feet and hundreds of thousands of gallons of water.

Hackman pleaded with those lemmings to join their group and move upward, but the lemmings continued downward to their certain, violent, drowning demise.

"You're going the wrong way, dammit!" yelled the priest.

Think of this book as Gene Hackman.

The easier path—the path to produce art for its own sake, for acclaim, or for vanity—is to travel downward. It is a well-worn path to panic-ridden discussions of institutional survival (never a goal), financial ruin, and taking money from an increasing number of toxic donors, all of which will be discussed.

The harder path upward is the one that can lead to success—producing art as a tool of community impact in order to help people. It is to remember that of the words, "Nonprofit," "Arts," and "Organization," the word "Nonprofit" is far more important than the other two.

If, after reading this, you insist on traveling the "art" path instead of the "nonprofit" path, all I can say is this:

You're going the wrong way, dammit!

Foreword

Relationships.

They're delicate and fiddly.

On the pages that follow, you will find a lapel-yanking invitation to examine the relationship you have to the arts in your life.

In relationships, we find our most heart-opening, soul-stimulating experiences. We lift others, and they lift us, and on and up it goes in a collaborative chorus that feels glorious for all.

Relationships can also take us on a blurring ride, battering us, only to deliver our brokenness to a lonely spot of contemplation: "What was *that*?" Relationships have that towering, undeniable power.

Somewhere in the middle of this high and low is a spot, a sweet one, where relationships break us open and sway us to reconsider our beliefs, ideas, and needs. Alan Harrison's *Scene Change* is exactly that challenge, that record-scratch moment.

For anyone who is involved in, interested in, or a beneficiary of the arts, this book is a call to form a new, forward-curious relationship with the live, artful performances you ingest and support. Whether you are an artist, administrator, donor, patron, foundation, your city's cultural official, or an occasional ticket-buyer, take this as the brick it is intended to be—let it crash through your window and thud down. *That one brick will be the first in establishing a new, sturdy foundation to a more enlightened relationship.*

Alan's tone is urgent. And no wonder.

TRG's recent state-of-the-industry report (September 2022) revealed that revenue from performing arts ticket sales in the US and Canada was down 18%. Companies were selling 26% fewer tickets than before the pandemic. Philanthropic revenue from

3

individuals was down 25%, with a 13% decrease in the number of gifts. These realities coat what was already precarious footing for the performing arts.

With *Scene Change*, Alan examines several root causes that have led us to this gray-skyed predicament. Truth? The lackluster performance and limited impact of arts organizations have been long in the making. Arts administrators and boards have passed down to us practices and cultures that have been bred over decades. Our margins have thinned and as a result our appetite for risk is next to nil. Our arts now require consideration beyond the lights, camera, action. Our beloved orchestras, theaters, dance, and opera companies need to be bigger.

Let's consider how particular actions create real trouble for us, all the while preventing us from making life-changing impact in our community.

A few years ago, TRG was working with a $4.7 million, US-based ballet company. The organization was stellar (albeit scrappy) in its fundraising abilities. They got results. TRG was engaged to analyze the transactional loyalty of the company's patrons based on each household's frequency and recency of transaction (subscription, single ticket, donation) and the monetary investment of those transactions over a five-year period. As we cracked open the analysis, we gasped: a mere 0.05% (87 households) of the database was making up 53% of the ballet's total patron income. The very life of the organization was held by 87 people, with most of their interaction provided via donation.

Together with the client, we examined the CRM file for each of these 87 households: had they donated this year? It was late May, and the fiscal year was ending in a month. Our team began to sweat upon learning that many had not sent in their donation. Their *six-figure* donation. Why had they not donated?! No one really knew the answer. More sweat.

As the fiscal year concluded, 44 of those 87 households (51%) downgraded their donation for a total loss of $554,000. In ONE year. Now, others upgraded, yes, which closed the aggregate gap significantly down to $140,000. But where did those *relationships* go? The organization spent the last month of their fiscal year begging for more money from those that had already given, masking the exits of 44 relationships—*relationships*. These numbers on a $4.7 million annual operating budget. The ability of this ballet company to expand its thinking beyond survival was leveled flat.

In the months following, the company reached out to those now-dormant donors. Some had life reasons for not renewing their gift, others contended they hadn't been cared for in the way they expected, and a few were candid about feeling their contribution had little meaning. Many didn't answer the phone.

How sad. How avoidable.

What plagues our field and repeatedly creates near-death scenarios like the one described above? Alan offers an experienced, care-laced perspective: we've got our relationship to the arts upside down and backwards. We produce and support art for art's sake. As for the remedy, Alan says we must earn and honor our status as a 501(c)(3) by reflecting and serving the communities we're in and the people that comprise them.

With a plea and gentle slap, Alan provokes us to reconsider all our arts relationships: our reliance on donors, the reasons why we sell tickets, the metrics we look at to judge success, our paltry attempts to create equity, and the very meaning of "Artistic Director" or "Executive Director" titles. On our field's behalf, Alan has grown impatient. He sees absolute disruption as the catalyst to change. From Chapter 4:

What if nonprofit arts organizations chose to run like the nonprofit service organizations that they were intended to

become? How do we get to the part where boards ask about the welfare of the people served rather than the financial results of the latest production/event/exhibition? What if they happen to engage in the arts in order to fulfill a societal need? What if they acted like a refugee protection society instead of a racetrack? What would that look like?

Alan paints a compelling case, backed by quantified examples, for how our nonprofit status can propel positive societal change. If we reset our relationships, we can conquer hunger, homelessness, racism, and loneliness. Compelling, indeed.

If you're a data-geek like me that needs an appetizer of transactional proof that the arts can have a collective impact, let me serve that to you here:

In a large-scale, community-wide study of nearly 1 million arts transactions from 17 organizations, 38% of all patrons that bought tickets and/or donated to 10 or more different organizations ("culturally promiscuous") were transactionally more loyal to each individual organization (vs. 12% of patrons who only engaged in 1–4 organizations across the community).

We see this result time after time, yet our organizational relationship to fellow community arts organizations is defined by "yours" and "mine." How might our community feel about that proprietary behavior? What do we collectively lose by staying in our lanes, producing art for art's sake, instead of focusing on the real change we can bring about in our communities?

As I began to read Scene Change, I felt discomfort. You might, too. But that is by design. Allow this brick to break through your window and let in some fresh air. Art, after all, is a living, breathing thing, and it is ready for a new relationship. Prepare to be courted.

Keri Mesropov
Founder and Executive Director
Spring Talent Development
Former Chief Talent Officer, TRG Arts

Acknowledgments

Along with the people mentioned in the book, I'd like to acknowledge the encouragement, inspiration, and wisdom I have gained from the following:

Danny Harrison, my brave and brilliant son
Donna Oslin, my brilliant and brave partner in crime

Robert and Kathy Bordiga
Judith Bowtell
Stacey Bridge
Becky Bruhn
Thomas Cott
James Cyzsz
Allen Fitzpatrick
Lisa Getzler
Leonard Jacobs
Diane Gottlieb Rich
Jill Robinson
Janine Schloss
Russell Willis Taylor
Parker Tenney
Tim Ward
Father Manuel Williams
Tim and Nancy Woodland
Jennifer Zgurich

And the hundreds more whose names have slipped through my Swiss-cheese memory. Thank you all.

Introduction

Have you ever had a $15,000 payroll due on Friday with only $500 in the bank? And it's Wednesday? And suddenly, your artistic director has a fit about the poster art for the play, screaming at the marketing director, causing her to quit on the spot? And you're so panicked about the lack of money that you *don't* ask for help, instead going into paralysis mode and doing the stupidest thing you could do—ignore the bad behavior and put a cash advance on your own credit card?

I did that.

Yeah, I know. Dumb.

Because of that idiocy, I started to re-evaluate what it meant to run a nonprofit arts organization. Not just an arts organization; a *nonprofit* arts organization. Surely, it couldn't be just putting on plays and dealing with divas (both performers and donors), right? If an arts organization were a charity, there had to be some public good, didn't there? Was art a public good if you couldn't measure *how* good?

At the onset of my consulting career, I asked artistic directors across the industry (theater, symphony, dance, opera, museums, etc.) what "nonprofit" meant to them. Originally, it was an icebreaker, but ultimately, more than any other question, it spoke to the heart of the problem.

In the main, responses tended to center on the idea that "nonprofit arts organization" is a basic legal term, and not a term of meaning. To most, it simply described any arts organization that wanted to reap the benefits of tax exemptions and accept donations to defray the costs of producing art.

That was eye-opening. More than that, it was validating.

After reading the IRS' description of what qualifies as a 501(c)(3) organization, even years ago, I had wondered why the arts were never mentioned as an exempt activity—and yet there

were so many nonprofit arts organizations in existence. Could they all be misrepresenting themselves to the government? All of them?

Epiphany.

In case you've never read the statute, here is the relevant text from Section 501 of the IRS Title 26, Subtitle A, Chapter 1, Subchapter F, Part I, Subsection (c), Sub-Subsection (3). Look for the area in which the arts are specifically mentioned as exempt purposes:

> Corporations, and any community chest, fund, or foundation, organized and operated exclusively for religious, charitable, scientific, testing for public safety, literary, or educational purposes, or to foster national or international amateur sports competition (but only if no part of its activities involve the provision of athletic facilities or equipment), or for the prevention of cruelty to children or animals, no part of the net earnings of which inures to the benefit of any private shareholder or individual, no substantial part of the activities of which is carrying on propaganda, or otherwise attempting, to influence legislation (except as otherwise provided in subsection (h)), and which does not participate in, or intervene in (including the publishing or distributing of statements), any political campaign on behalf of (or in opposition to) any candidate for public office.

You're right. It isn't there.

There are very specific buckets in which exemptions may fall, except one word in the second line: "charitable." "Charitable" has a host of meanings and has been used as a "miscellaneous" item for many years now, especially in arts organizations, because there is no other category under which they fall.

Happily, the IRS has defined "charitable" for everyone, which saves all of us from having to define it ourselves:

The term "charitable" is used in its generally accepted legal sense and includes relief of the poor, the distressed, or the underprivileged; advancement of religion; advancement of education or science; erecting or maintaining public buildings, monuments, or works; lessening the burdens of government; lessening neighborhood tensions; eliminating prejudice and discrimination; defending human and civil rights secured by law; and combating community deterioration and juvenile delinquency.

"Charitable purposes."

That was it. The jigsaw puzzle's last piece. The business of creating art is not easy. But is that because the goals are more tied into the production of art rather than the charitable goal of making your community better?

When we use the word "impact" in this book, what we mean is the betterment of society, not a powerful artistic achievement. The latter can be magnificent, but if the needy in your community are not being cared for—the issues of hunger, discrimination, social justice, homelessness, animal cruelty, and literacy are among the most prevalent targets for nonprofit organizations— then there is little impact. Without impact, arts organizations reveal little in the way of indispensability for the community that granted them the ability to forego some taxes. Charitable purposes deal with impact, not with pretty or poignant art that entertains the elite.

Recently, a former artistic director for a huge American nonprofit arts organization publicly bemoaned the decline in the number of acting companies: "Why are we closing our entry points for young talent? Why do our priorities always seem to be on admin rather than artists? It's time to reimagine." In his/her opinion, what stakeholder has the art served when things were glorious? The company? The artists? The production? The talent?

Wait, what?

Where is the community in all this artistic wailing? Maybe, and I know this sounds kooky to some, the fact that the community (through its government) actually *allowed* you to become a nonprofit in exchange for charitable activities means it's the community that should come first.

A wonderful friend once asked in rebuttal to community-centered, measurable impact, "Isn't art enough?" My response then was as it is now: "Art being enough is not the question. Art is enough. But nonprofit arts organizations are not art. They don't even create art; that's what artists do. They are charities, in the business of creating positive impact using art as a tool."

To be clear, "positive impact" does not equate to an audience member becoming spellbound by a performance. It only succeeds when a whole community becomes more functional. Measurably, quantifiably more functional.

How does your art benefit any of these members of your community? How do you quantify that—from their vantage point?

The answer to that question is specific to your community's needs and the operations of your nonprofit arts organization in addressing them. Each community is different, of course. But if your community has glaring needs that beg to be addressed in more creative ways than town halls and community planning sessions, this is where you can quantify your impact.

For example, let's say your community is defined geographically. It is a small section of a large city in which housing is expensive, wages lag behind inflation, and there are homeless encampments everywhere. How can your arts organization tackle these problems?

Can you present art to those homeless people to elevate their lives? Can you work with social service organizations to provide comfort to those with mental health problems? Can you

use your bully pulpit to speak to the issues with your art rather than leaning on entertainment as a goal?

Then, to quantify your impact, tell the world how many homeless people have been introduced to housing because of your work. Did you increase your attendance of people with no means? By how much? What happened after they came? Did you host a job fair or include them in your volunteer work? What was the financial impact of that for those people?

Continually ask yourself why your community is measurably better because of the work you do. You'll be cajoled, coaxed, hectored, and maybe even bribed to find a way to produce impact instead of producing art. You might even get offended, or at the very least, impatient, looking for some all-encompassing answer that does not exist. Disequilibrium is the first step toward change for the better. There are ideas and samples nearer to the end of this book. They're not all-encompassing, to be sure, but you'll get a better sense of where you need to start.

But before you get to that, you'll see a lot of questions within these pages. A lot. You've seen some already. Many of them don't have ready answers.

These questions are not a final exam. They're not even a pop quiz. Don't try to get an A; that's not the point. There is no A. Just as there is no F. These questions have been posed to determine the best ways to incrementally increase your effectiveness by increasing your impact on your community.

Use them broadly. Ask any and all stakeholders. Get the data. Without the data, you're just guessing.

Three final thoughts. The first is to keep a pen handy as you read so that you can write in the margins. Books aren't sacred, even the Bible. The word "Israel" translates in English to "wrestling with God," an idea that change is inevitable and

stasis is dangerous. It also refers to the provocative nature of words—that none are to be taken as, ironically, gospel.

So, go ahead and underline areas of concern. Circle paragraphs that surprise you or sentences that usher new ways for you to look at old problems. Rip out entire pages, if you like. It's your book. As the old Lay's Potato Chips slogan went, "Crunch all you want. We'll make more." You can always buy another copy.

The second thought is often offered in these kinds of books, but seldom followed. Fail fabulously, many times, with gusto. If you fail once and only once, you're just not trying hard enough. If you never fail, you're coasting. Remember that no mistake is fatal unless someone actually dies.

The third thought is crucial: if you have to tell someone that something is relevant, it's not.

Chapter 1

Dependence and Show Biz

Broke, Bedraggled, and Bewildered

I never set out to be an arts administrator, let alone an executive director. I didn't even understand what a nonprofit organization was. I was just another struggling actor in New York in the early 1980s. At one point, I had about $5 in my bank account. And I needed, as most unemployed performers put it, a *job* job.

A friend helped find me a job handing out flyers at the TKTS booth at Times Square at 47th and Broadway. Then, TKTS sold day-of-performance, half-priced tickets from a dilapidated trailer. It was commerce on the wild and woolly side, open every day.

TKTS was right in the middle of Times Square. Around the corner from the Gaiety (good chicken soup) Deli. Around the corner from the Gaiety (live nude male porn) Theatre.

There was a homeless guy who came by TKTS every day. Let's call him Sam. Usually drunk on Night Train. Sometimes with a shopping cart, sometimes without. The kids who worked as runners (no sophisticated system here: messengers literally ran from the theaters to TKTS with a new shipment of tickets to be sold at half price) would make fun of Sam, even though in actuality, most were terrified of him. Sam was a large, fortysomething Black man with filthy, torn, military-type clothes. He spoke in a garbled *basso profundo* voice that had a deep and rich timbre to it. You just couldn't quite figure out what he was saying because he lacked the requisite teeth to be understood.

Sam used to propose to at least one of the women who worked there every day. He panhandled. At the end of my shift, I always saw him take his shopping cart and roll up toward

57th Street. And we wouldn't see him again until the next day. Every once in a while, we'd see him waking up after a bad night sleeping underneath the TKTS trailer, emerging into the light like John Goodman in *Raising Arizona*.

It struck me one day that Sam's life was dependent on the theater business. And I don't know that he ever saw a play in his life.

Subscriptions Are, at Most, a Vein; Certainly, Not the Aorta

After retiring from the acting business and the producer business, I embarked on a brief, 15-year foray into nonprofit arts organization marketing, followed by 15 more years as an arts executive, board member, donor, and consultant.

On the marketing side, a great deal of energy was spent on the garnering of subscribers. The history of subscriptions is not an interesting subject. But the knowledge that it has been around for 200 years might be eye-opening for those who believe it's the salvation of the industry. Regardless of what you hear from the old-timers, the future of nonprofit arts organizations, in America at least, does not depend on the following sentence:

Subscription revenue is the lifeblood of our institution.

Turns out, it's a flaming pantaloon lie.

It's not that subscription revenue is unimportant. It's that subscribers are no more loyal than any other ticket-buyer. They might simply be folks who wanted to get multiple dates put on their calendar so that they never had to think about it again. Subscribers were prevalent in high-income households where only one person was in the workforce. The homebound body's job was to plan each year's social calendar. Knocking off six weekends with one phone call was very convenient. Likely, all their ticket purchases were made this way—six to ten at a time.

Some people like the routine aspect of subscriptions. They'll go to the same restaurant every time they attend a particular arts event at the same venue. They'll park in the same spot. They'll arrive at the same time, down to the minute.

There are still many arts companies—large and small—that excessively honor their subscription buyers. Subscriptions were (and are) just another illustration of the clubby reputation of the professional arts industry. Some arts organizations only think of their single-ticket buyers as potential subscribers, not as patrons with their own loyalties and values.

The arts have not shaken that horrible, elitist reputation, at least thus far. In fact, elitism in the arts is the single most devastating and antipathetic detriment toward building audiences for a nonprofit arts organization. Worse, elitism and inaccessibility obviate a great deal of charitable impact. It's hard to claim that you're helping the underserved in a daily environment of exclusivity.

In the arts, there exists an egregiously divisive instinct to keep people out. It is, for lack of a better word, stupid.

Which brings us to this conclusion, at the center of everything else you read in this book:

In the nonprofit arts, donors donate so that donors may attend.

If that doesn't strike you as elitist, perhaps you're not paying attention.

Let's dig into that.

Donors Donate So That Donors May Attend

How Do You Find Out What Your Donors Actually Want?

What *you believe* your donors want may be in strict opposition to what your donors *actually* want.

Try these questions on for size. They're direct inquiries about your work as a nonprofit arts organization. In my experience, I have found that donors may choose to give (or not to give) based on answers to these key questions. Ask yourselves:

• *Why does your nonprofit arts organization do what it does?*
Donors are not stupid. They already know WHAT you do. When you can make a compelling case WHY you do it, you're on your way to a good relationship. Author and optimist Simon Sinek, whose best-seller *Start With Why* has inspired millions to change the way they do business — for the better — put it best:

> Very few people or companies can clearly articulate WHY they do WHAT they do. By WHY I mean your purpose, cause, or belief — WHY does your company exist? WHY do you get out of bed every morning? And WHY should anyone care? People don't buy WHAT you do, they buy WHY you do it.

• *How is your process better?*
Show why you provide great services, and why those services are distinctive to your organization. What is it that you do that accomplishes impact, regardless of the cost to do it? Cost-efficiency is secondary to impact in that regard. The idea that overhead, for example, is something that should be cut in order to prove a higher percentage of donated dollars goes

to "programming" is fading into obscurity, except for a few dinosaur donors out there. Your task is to persuade donors why you provide better, clearer, and more positive impact to your community.

- *Why your organization?*

Why is your organization more deserving than one doing a similar thing? With malice toward none (meaning: don't trash the competition, simply amplify your organization's distinctive qualities), show why your organization is different and uniquely effective.

- *What does the donor really want to achieve in life?*

Research like crazy. Learn what drives your donor before you ask them for money. And thank them personally whenever possible (in your own handwriting, not in an impersonal, mail-merged letter—even if you cross out the salutation name on the letter and write in the person's first name...very tacky).

Take your time and answer the above questions carefully for your organization (and yourself, for that matter). Rather than rushing to a pat answer, think it through. Discuss widely, with folks within and outside your organization.

There's a separate question for arts organizations that you'll have to consider. Not to mix Romance language phrases, but it has little to do with your *raison d'être* and more to do with your *modus operandi*.

- *Does your organization shame those who do not donate?*

When is the first time you ask a ticket-buyer to donate? How many times have you asked them to do so before they have experienced the art? Do you ask for a donation in any way (print, email, phone call, the back of the ticket, the advertisement, etc.) *before* the first word of the play, the first

note of the symphony, the first step of the dance, the first entry into the exhibition hall?

Any ask, no matter how trivial, reveals a big problem if you've never had a relationship with that customer before that moment. And yet, "DONATE NOW" is on the home page of your website. Perhaps you've included a donation line in the online shopping cart. There's a note in the confirmation email. It's on their program, several times. It's on the walls, including the bathroom walls in some cases. It's spoken by someone on stage before the event.

Is there any other organization in the nonprofit sector that works like that? Where *the user* is begged to contribute money?

Are starving people asked to donate in order to enter a food bank so that they can get free food?

Are homeless people asked to donate to a shelter so that they can get a free bed?

Poor Fido. Fido was found tied to an old hi-fi set in the middle of a warehouse. There was a record playing on the stereo, a scratchy 45 of Sarah McLaughlin's "I Will Remember You," set to repeat by the old automatic turntable. Fido was found on her back with all four legs in the air, weeping and wailing, "Rah Rill Reremrer Rooooooooooo!"

Fido was taken to a special nonprofit animal rescue for treatment. At the rescue, two other dogs invited her to lunch where after about two hours, she was told that she could get better treatment, a more comfortable and exclusive kennel, and her name on the wall if she donated 100,000 Milk Bones.

The point of that little shaggy-dog story is this: outside the arts, are there any nonprofits in which the donor is also the user? Over-soliciting is among the most quoted reasons donors give for not giving a second time. Shaming people into giving by throwing dozens of asks at them never works. It only establishes your elitist tendencies to the masses.

One might argue that private schools—both universities and prep schools—have taken donations from users, or rather the

users' parents. Ask Lori Laughlin or Felicity Huffman about that (google it, kids). The argument that private schools force donors' parents to donate so that donors' children benefit is tenable, albeit one step removed.

Still, for what are private universities and prep schools infamous? They are notoriously, openly, baldly, straightforwardly elitist.

Here's the difference: private schools have never meant to help a community, except the immediate community of its stakeholders (alumni, professors, etc.). Nonprofit arts organizations, at least in theory, are meant to help a community with its most urgent issues, using art as a tool.

The same entanglements endured by private schools who want, for example, to right past wrongs by establishing positive programming in diversity, equity, and inclusion (DEI)— entanglements that have led to cries of "reverse discrimination" (a racist trope), for example—are also bogging down the practices at nonprofit arts organizations, whose record on exclusion has been eerily similar. But still, after all the manifestos and discussion, large nonprofit arts organizations are still, in the main, bastions of whiteness.

Perhaps there is a way to reduce elitism at nonprofit arts organizations. Read on for some ideas, but note that a great deal of change is going to have to occur. There are more obstacles to come.

We Can't Make It on Tickets Alone, So Let's Sell Exclusivity?

How many times have you bemoaned the fact that some middling percentage of your nonprofit arts organization's income comes from the ticket revenue? And how many times have you used it as a selling point?

"Only 50% of our income comes from the sale of tickets." Something like that.

If you attend 100 nonprofit arts performances, I would wager that you hear it or read it no fewer than 100 times. And yet, the price of the ticket isn't exceptionally low, is it? When you pay $800 for four tickets to an opera, do you want to hear that your payment is insufficient—and that you should pay more?

Donors with deep pockets contribute to the organizations and receive special benefits. At the Detroit Opera House, for example, if you give just $20,000, you receive the following:

- Invitation to attend an annual donor conversation with artistic leadership
- Early access to online sales for single tickets, special performances, and events
- Invitation to opera rehearsal for two guests
- Inclusion on donor listing in programs books
- Invitation to pre-rehearsal donor reception for two guests
- Two Detroit Opera House Parking Center vouchers
- Two beverage vouchers redeemable during any Detroit Opera dance or opera performance at the Detroit Opera House
- Admission to Herman Frankel and Barbara Frankel Donor Lounge for four guests for the entire season
- Complimentary valet parking
- Invitation to the annual DiChiera Society thank-you event for two guests
- Complimentary coat check in the Vincent Lobby
- Opportunity to observe a masterclass
- Concierge service for ticket and subscription purchases and exchanges
- Invitation to exclusive Meet & Greet with guest artists for two guests
- Invitation to travel with the Detroit Opera House [note: not the travel itself; just the invitation]
- Opportunity to access box seats in the Detroit Opera House

- Invitation to annual donor lunch with President & CEO for two guests
- Invitations to unique, insider experiences featuring artists, musicians, composers, librettists, and/or production team members for two guests
- Donors at this level gain access to curated, personalized experiences that reflect their meaningful commitment to opera and dance.

When you donate lots of money, you get lots of stuff. And you get it right in front of everyone else who did not donate money. Exclusive rooms are yours in a building owned by a charity.

There's nothing outwardly wrong with offering benefits to those who pay more for them. After all, when you give $20,000 to the food bank, you get, uh, well, that is...

A plaque maybe? Mentioned at the annual donor lunch? A receipt for your gift?

You certainly don't get exclusive access to the Herman Frankel and Barbara Frankel Donor Lounge, plied with drinks and snacks, getting your shoes shined, cordoned off from the general (*eww*) public. It's a clubhouse for café society, with the unwashed hoi polloi opera-goers kept out by a paid security guard. (No, really. A security guard.)

Exclusivity is not the goal of any nonprofit. It shouldn't even be part of the conversation, should it? The "elitism" label that has affixed itself to every nonprofit arts organization can be attributed to just this kind of gilt-edged pandering to the über-wealthy. And it causes toxicity among some donors, namely those who come to expect to be adored.

Not that the Detroit Opera House is the only large organization to lavish such glorious benefits onto its richest donors.

When you give $50,000 to the San Francisco Symphony (the cost of living is much higher in San Francisco than in Detroit, of course), you receive the following:

- 10% off SF Symphony Store
- Early access to single ticket pre-sale
- Access to virtual events
- Access to Friends "In the Rehearsal" event
- Two tickets to SF Symphony Youth Orchestra concert
- Acknowledgment in all SF Symphony program books
- As many as six additional tickets to Symphony concert
- Wattis Room access
- Access to post-concert receptions with the stars of today
- VIP ticket services with waived fees and seat upgrade opportunities
- Access to Concertmaster's Reception and Chamber Music concert
- Preferred seating services
- Season launch event with Esa-Pekka Salonen and SF Symphony leadership
- Complimentary parking at concerts
- Invitation to Evening with the Music Director
- Access to SF Symphony musician showcase reception.

In case you're wondering about what the Wattis Room is, here is the description from the Symphony's website:

San Francisco Symphony donors at the Baton Circle level and above enjoy exclusive dining privileges in the Wattis Room before concerts and during intermission.

Relax in an elegant atmosphere and experience attentive service inside the heart of the Davies Symphony Hall. Enjoy a three-course meal from an inspired fusion menu of California and French cuisines, paired with an impeccable selection of wine and spirits. Or, refresh during intermission with coffee, cocktails, artisanal cheeses, and desserts.

The Wattis Room is open to members for dinner service on concert evenings beginning at 5:30pm and concert lunches at

11:30am. Reservations are not required during intermission.

Are all those benefits equivalent to what you get when you donate $50,000 to a refugee protection charity? No. So why do arts organizations find the need to bribe their donors?

Donors know that most arts organizations will bend over backwards—or forwards, as the case may be (with all wildly inappropriate connotations of that phrase at play here)—to secure a donation from any wealthy person. And toxic donors take advantage.

A toxic donor is one who donates money with an expectation of power that exceeds that which is due a typical donor—even one who donates the same amount of money. Not every big donor is toxic; in fact, most are not. But there are those who leverage their donation to achieve some status extremes that can (and often do) make your organization's best staff members shudder upon the mention of their name, at least in private. Every large arts organization has at least one. They tend to bully (even with a velvet fist) people into submitting to their whims, using their donation in ways that would impress even the best extortionists in the criminal world.

As a constant reminder about who *has* money and who *needs* money, toxic donors take it upon themselves to dominate the development machine in your midst. In arts organizations, it creates an environment that excavates Grand Canyon-esque cultural chasms among all departments: marketing, artistic production, education, etc.

When a contribution arrives without expectation of anything (except effective, impactful work, of course), that donor provides positive energy to the organization, giving it confidence that it is performing its intended duties. These donors are gladly stewarded toward higher levels of participation, as in any nonprofit, but their motives are relatively pure.

But what motivates a donor is nothing your company should assume. You have no idea what motivates any particular donor because you don't live in that person's head. Ask those questions posed earlier. Because I can guarantee the answer will never, ever, ever be to choose a benefit from a 27-page menu of goodies and perks. Those incentives can only lead them to this assumption: you only want to associate with them because, and pardon if I get too technical here: *"cha-ching."*

Think of it this way: at a party, would you spend an hour with a Jewish person talking about Jewish things? If you do, and the conversation is cringeworthy (and oh boy, is it ever), breathe deeply and stop. The only reason you're talking to them is because they are Jewish.

I've been that Jew, and the experience is eye-rollingly embarrassing. I've also been that white guy who made the mistake of talking only about Black issues with a Black friend. Mistakes are par for the course for all human beings, such as we are.

So, here's a good rule to follow: *speak to a potential donor just as though that person were—and this is important—a "person."* Don't speak to that person as though they were a potential donor.

If that person wants more adulation than you are providing, that person is likely toxic, or at best, able to be bought off with empty praise and fawning, which is exactly what they'll require from that moment forward. Forever and ever.

The higher the rank, the more familiar the relationship.

Develop your relationship into something akin to a love for a good movie. Sharing that love might make that other person's life better. As has been said before and will be again: it's called "development" for a reason. It's about developing relationships, not begging for money.

So what *are* the factors that might motivate a particular someone to donate a particular amount of money? Never assume that a simple list will answer that question for more than one

donor at a time. For among other reasons, no one, especially someone with whom you are embarking on a relationship, wants to be part of your development plan. They want to help. Those are two very different things.

Generally Speaking, Donors Donate to Make a Positive Difference. But Not Always

A whole passel of factors goes into donating to a nonprofit, including generational attitudes toward institutions. The art of philanthropy is more complex than ever. Within each of those passels are sub-passels of human emotions, specifically loves and hates. Those sub-passels are at the heart of why a particular person will choose to donate at all. And those are only accessed by developing relationships, not by toys or goodies.

As Lisa Greer wrote in her superb book, *Philanthropy Revolution*, some of the most important issues defeating the entire nonprofit industry include lack of institutional trust, fundraising paralysis, and the ancient "rules of engagement." One "rule of engagement," for example, is the archaic and self-defeating notion that a good way to get a big gift is to have a chichi, 2-hour lunch with a donor, ending with an ask.

Like many writers on the subject, Greer doesn't believe that, generally speaking, people give to get that invitation to the private club.

And you don't have to look up data to discover that people do not donate by your cycle, but by theirs. Just because you have a year-end campaign doesn't mean that a gift by December 31 is one of their priorities. The lack of sensitivity toward the individuality of a donor can easily lead to mistrust and alienation toward not only your nonprofit, but all nonprofits.

According to research, only 52% of people in the US trust nonprofits. Why? Could it be that the sector's leaders only use one path to success?

Look at your donor base. Is it filled with "Greatest Generation" folks and not so many in the "Millennials" group? Are they mostly white? There's a pretty good reason for that.

You might only be talking to donors as though they were older white people. And you may believe, somehow, that a Millennial wants exactly what a Greatest wants for their world. It follows, then, that you might be speaking a language about institutional importance, using words like "membership," "flagship," "venerable," or "historic" to a potential supporter whose chief intention as a donor is to make their own future better, not necessarily to do so for their grandchildren.

The Resource Alliance reported the six characteristics of modern philanthropists. Do you speak to these issues when you connect with a potential donor? Or do you just talk about your latest production?

- The Need to Make a Difference: Defined as the competence to choose or create environments best suited to their needs/values and where they are capable of making a desirable difference
- Autonomy: A sense of self-determination and the ability to resist social pressures to think and act in the manner one desires
- Positive Relations with Others: The need for warm, satisfying and trusting relationships with others
- Growth: The feeling of continued development, realizing one's own potential, seeing oneself as growing and expanding, seeing improvement in self and behavior over time, being open to new experiences
- Purpose in Life: Having goals for the future and a strong sense of direction
- Self-Acceptance: The ability to experience positive feelings about one's sense of self in the past.

Regarding the last one: the ability to experience those positive feelings about one's sense of self in the past is not the same thing as a nonprofit arts organization presenting works from the past. The two ideas are completely separate. What the research is describing is closer to the notion of a life not wasted in irrelevance or meaninglessness, not nostalgia.

As you drone on at that lunch at Chez Chic about the great art your organization has produced for the past umpteen years, they may be completely turned off by discussions of the past. Are these potential donors just insensitive to the place your organization holds in your community? Or are you touting things that do not matter to them? Conversely, do they care about things that do not matter to you?

Baby Boomers and the generations that precede them have an abiding respect for history. The generations that follow do not; rather, they are more attuned to specific and new cultural attitudes.

In 2015, *Smithsonian Magazine* published a story about young people's attitudes and knowledge of history. A group of students at Texas Tech University (213th ranked national university, according to *US News*) were asked three questions:

1. Who won the Civil War?
2. Who is our vice president?
3. Who did we gain our independence from?

Students' answers ranged from "the South?" for the first question to "I have no idea" for all three of them. However, when asked about the show Snookie starred in ("Jersey Shore") or Brad Pitt's marriage history, they answered correctly.

—*US News & World Report*

Likely, like 99% of those surveyed in a different study, they can't name the country that dropped the first nuclear warhead on a sovereign nation, but they can name all the ingredients of a Big Mac.

Are Texas Tech students stupid? Is America stupid? No. But like many people, they do not put their trust in historical data *if it does not affect them personally, right here and now.*

In my own experience, at a fun, 1960s-themed gala in Seattle in which the Boeing company purchased a table for its engineers, I asked the group the following question in a trivia contest: "Who was the second man on the moon?"

No one at the table answered correctly. It did not affect anything they were doing in the here and now. And these are people that build rocket ships and stuff.

The point is, we have to talk to people in a way that affects them, not in a way that affects us. Put another way, we have to stop treating every potential donor as an old white person, or else the only donors we'll get are old white people. Lisa Greer agrees: "Let's not kid ourselves. Unless we change the old rules of engagement, which are institutional relics, we're going to continue to bump into this problem of trust."

Quickie #1

For too long, nonprofit arts organizations have depended on the idea that their art—not the impact on the community—is their purpose as a great institution. Changing that ossified message, and the way it is delivered, will make or break their collective future. Baby Boomers, Generation X, Millennials, and Generation Z are not concerned with the idea of institutional health, according to the Blackbaud Institute for Philanthropic Impact. (Ironic, isn't it, that an institute reveals that most generations are not concerned with the idea of institutional health?) In the main, those four generations are less concerned with leaving a legacy, except in healthcare and climate change.

They are more concerned with helping the people who are on the planet *right now.*

Giving to *right now* causes increased in 2020 in comparison to 2019, according to Giving USA. Environmental causes showed an increase of 11.6%. Human services, +9.7%. Public-society benefit (social justice causes), +15.7%. Yes, the COVID crisis had something to do with that. But it was already happening. There were increases in the previous years in all these categories.

And the arts? A decrease of 7.5%. And that followed a decrease of 2.1% the year before.

Does your arts organization help people on the planet *right now*? Can the people of your community trust you enough to help those that need the help? Will that cause them to help you?

Or are you still trying to appeal to those that want their name on the building so that they can show off their wealth to their neighbors?

Toxic Donors, Sin Sources, and Other Things That Go Bump in the Night

Have you ceded power to those on your board and in your giving community that prefer the exclusive experience and will pay high prices to get it? Not good. If you accept categorically elitist, potentially racist behavior from others for the sake of money, well...

As comedian Chris Rock famously said, "If ten guys think it's ok to hang with one Nazi then they just became eleven Nazis."

Toxic donors require constant toadying—weighted input on the inner workings of the organization, making staff deal with unspoken (or sometimes, spoken) threats of withholding financial support, or continual adamant requirements to be thanked or recognized at every possible opportunity. Toxic donors tend to drain the organization of its energy. They cause staff members to be disillusioned into believing that only the "1%" matters.

In the arts, artists of all kinds depend on the notion that their work is expressive. That's the unwritten tradeoff: they'll accept a lower salary if they can feel a sense of power upon the creation and presentation of art. However, when they're forced (by management, especially disconnected board members) to compromise on the premise of the art being chosen, they'll start reading the trades to find a better job. At that point, they might as well build Toyotas.

When toxic donors move an entire organization toward their own preferences (and prejudices), everyone loses. What do you do with a toxic donor? Sounds like an old sea chantey.

In this "No-Win Scenario" of appeasing the racist donor, how can you possibly succeed?

There is no way to win with toxic donors. When you allow them to wash their reputations through your organization, your organization gets just as tarnished as a clean dishrag wiping grime off a leaking BMW engine. In the long run, all you have as an organization is a) your value to the community, and b) your own values system. When the prostitution of the latter negatively affects the former, you have nothing. And the whole sector can suffer the consequences.

When any organization accepts money from a toxic donor, the feeling among the community in which it serves—right or wrong—is that *the entire sector of that industry* might accept money from toxic donors. If that proved to be true, trust in the values system of every organization would come into question.

At which point, the discussion does not become, "Do nonprofit arts organizations prostitute themselves?" It becomes a question of price.

But toxicity does not end with power brokers.

What about those series of donations that fall into the murky area of "sin sources"? Sin sources, for these purposes, refers to people or companies that use donations to launder their poor public image.

Mortimer D. Sackler, along with his brothers Raymond and Arthur, bought Purdue Pharma in 1952. Just in case you were in an opioid-induced coma over the last few years, Purdue Pharma made OxyContin, an opioid that the company knew was not only dangerously addictive, but the cause of thousands of deaths. The family was, as the *Washington Post* put it:

> mired in legal action, investigations and looming congressional inquiries about their role in marketing a drug blamed for a significant early role in an epidemic of overdose deaths that has claimed the lives of hundreds of thousands of Americans since 1997.

That legal action came to a head in March 2022, when Purdue Pharma agreed to pay $6 billion in damages (the figure could still end up as high as $10 billion). In addition, the Sackler family had to give up control of the company and use all its future profits to fight the opioid crisis. Finally, the family was directed to apologize. The apology read like the adult version of a fifth-grade bully on the playground having to apologize to a third-grader for stealing his lunch money.

> The Sackler families are pleased to have reached a settlement with additional states that will allow very substantial additional resources to reach people and communities in need. The families have consistently affirmed that settlement is by far the best way to help solve a serious and complex public health crisis. While the families have acted lawfully in all respects, they sincerely regret that OxyContin, a prescription medicine that continues to help people suffering from chronic pain, unexpectedly became part of an opioid crisis that has brought grief and loss to far too many families and communities.

Mortimer Sackler was a board member of the Solomon R. Guggenheim Museum for over 20 years. He and the Sackler family had been huge donors over the years—totaling $9 million or so between 1995 and 2015. However, on March 22, 2019, the Guggenheim Museum in New York made the decision to no longer accept financial gifts from Sackler.

The timing was unusual. It is not as though Purdue Pharma suddenly became corrupt that month. In fact, according to the *New York Times*: "In 2007, Purdue's parent company pleaded guilty to a federal felony charge of misbranding OxyContin with the intent to defraud or mislead."

The key information here is not the gifts, but the timeline:

- 2007—guilty plea
- 2015—final gift from Mortimer D. Sackler
- 2019—Guggenheim chooses to deny gifts from the Sacklers

One is left to wonder about the ethical turpitude of the Guggenheim, a famous and large nonprofit arts organization, between 2007 and 2015, when an indisputably blameworthy Sackler family member continued to sit on its board and assisted in governing its direction and policies.

According to the Centers for Disease Control, in that same 2019, an estimated 10.1 million people aged 12 or older misused opioids. Of that figure, fewer than a million used heroin; the rest used prescription opioids, the most prevalent of which was OxyContin. The total opioid-related overdose deaths since 2013? It exceeds 280,000.

One can see why the Guggenheim—along with the National Portrait Gallery and the Tate Galleries in London—is refusing philanthropy from the leading purveyor of the most popular opioid maker on the planet. But does the gap in time that it took for those large nonprofits to make that decision show a lack of

courage? A wish for the problem to blow over? A lengthy and circumspect discussion on the subject?

Or did they wait until photographer Nan Goldin and other artists protested, as they did in February 2019? When did the Guggenheim, or any other large nonprofit arts organization now or seemingly soon on the verge of spurning the Sacklers, ever previously call into question their governing and financial relationship with a pharmaceutical serial-killer?

Who knows? Maybe there are arts organizations willing, for the right price, to change the name of their venue to the Adolf Hitler Theatre Center. Unlikely, but never underestimate greed born of scarcity.

What about the Harvey Weinstein Theatre Center? Given all of his work toward the creation of great cinematic art, that might be considered acceptable, right? After all, he produced the Best Picture-winning *Shakespeare in Love*. And culturally iconic movies *Good Will Hunting*, *Pulp Fiction*, and *The Lord of the Rings*. Does it matter that he is allegedly a serial sexual predator? Maybe it does. But if his estate managed to send you a hundred-million-dollar check on the condition of renaming your venue, would you cash it? Is that your price?

Would your nonprofit arts organization change its venue's name to the Jeff Bezos Theatre Center? After all, he has donated a goodly amount of his wealth to his foundation. And the foundation has given some of his money to schools and colleges across the country. But would you celebrate the man himself? Regardless of the fact that Bezos paid little to no taxes for years? Regardless of the brutal working conditions to which he subjects his warehouse employees? He's not a criminal, as far as we know. He's merely a horrible person. His company doomed thousands of small brick-and-mortar businesses to failure, causing downtown streets across the country to be filled with FOR LEASE signs. Only those who choose to sell their products as third-party sellers on Amazon—often in competition with the

price-dumping practices of Amazon itself—are still in business. But if he (not his foundation) gave you the same hundred-million-dollar check, would you cash it? Is that your price from this sin source?

What if your newly minted social justice program is there to expose, attack, and fight bad acts caused by companies like Amazon? Or your #MeToo art on stage or on the walls would be ideologically discordant with a gift from Weinstein, Bill Cosby, Matt Gaetz, or any of Jeffrey Epstein's clientele (such as, reportedly, Bill Gates and Prince Andrew)?

You don't still have a wing named after the Sackler family, do you? Really?

Where is the line between principle and pragmatism? Australian publication *ArtsHub* tackled the subject:

> Being pragmatic—and accepting the money for immediate benefit—may not be wise in the long term. The brand of the arts organization could from thereon be associated with the sponsor, which can cause long-term damage to the arts organization—especially when there is a belief (founded or not) the sponsor can compromise the integrity of the arts organization. The size of the sponsorship can also often be relatively small in comparison to the overall cost of mounting the event. The price of turning off artists and audiences may be a poor exchange.
> —Richard Watts, July 2, 2021

Whether they feel entitled, toxic donors have been treated as royalty in the past and now expect it. Maybe they're just plain bullies. You probably unconsciously uttered one donor's name just now. When they're also board members, these are the people who make organizational decisions unilaterally, simply because they have succeeded in cowing the other board members into submission. Or they've blackmailed your organization into

spending time, money, and resources on extra activities, using their own donation as that money on a fishhook.

When I worked with the Los Angeles Theatre Center (LATC), there was a donor who provided funding to invent a program important to him. As always, the artistic director looked at every large sum of money like an old Tex Avery cartoon, with eyeballs thrusting forward out of their sockets and a "BOING-NG-NG-NG-NG-NG" sound effect, pupils replaced with dollar signs, followed quickly by the sound of cash registers and slot machine alarms.

The program was to fund marketing support to bring in Latinx audiences, especially those who spoke Spanish as a first language.

Unfortunately, LATC had no Latinx program in place to market. All of its works were performed in English. And there was no audience from the Latinx market for white plays by dead men, such as Henrik Ibsen's *The Wild Duck* or the latest Icelandic hit play (both actual programmatic choices).

After one year, at a retreat, that donor (also a member of the board) was furious when the data indicated that the Latinx audience at LATC comprised only 9% of its total audience, even though Latinx people in Los Angeles comprised about 36% of the population. Rightfully, he slammed everyone under the sun and LATC never gained the trust of the Latinx community.

As was his wont, the artistic director—even though he had *still* not programmed a play in Spanish—blamed the marketing department. Right there at the retreat.

In this case, LATC should never have accepted the premise of the donation, at least not at that moment. In fact, the effort (partly because it was so hastily implemented, and partly because there was no inclination on the artistic side to start producing in Spanish) ended up costing more than the gift.

But these donors *love* your organization, they say. Likelier, they love the adulation you have to give them. Perhaps they

would love that adulation regardless of its source. Perhaps they just love the power they've wrangled.

Let's say they have a meaningful relationship with opera and your company is the local opera company. They love and want to support the continued production of opera. They may feel as though they are allowed to be a flea in the ear of the general director, making sure their favorites are always on the schedule, regardless of the opera company's charitable mission (whatever social need it has chosen to address). And finally, let's say those favorites always include a white cast, supers, musicians, and artistic team (even if—and often, especially if—that team is from another country). What's the harm in doing another production of *Madame Butterfly* with another terrific white soprano in yellowface?

There are no showers long enough or effective enough to clean the stench of dirty money from a sin source. Step in that muck once and it will stick to your soles—and your souls—forever.

Corporate Arts-Washing

What do you do with a toxic donor (earl-eye in the morning)?

Altria.

That is the Groucho-glasses-and-nose name that America's largest cigarette maker, Philip Morris USA, chose in an attempt to disengage its tainted reputation from Big Tobacco. The invented moniker begins with the same first four letters as altruism—undoubtedly on purpose. Over time, marketers of products that are associated with evil or death will always find ham-handed ways to shore up their image.

And it worked! You no longer read much about controversial donations to nonprofits from Big Tobacco. In Philip Morris'—er, Altria's—hometown of Richmond, Virginia (the state ranks third in tobacco-farming), the company donated $10 million in February 2014 to restore and rename the state's largest theater

to The Altria Theatre. There was little to no uproar at the time and none has occurred since.

What's next? The Smith & Wesson Playhouse?

The question is this: *why wasn't there an uproar?* How many thousands of people have died over the years, over the decades, because Altria inserted highly addictive additives into their cigarettes so they'd burn down to the ash more quickly, causing the smoker to light up another one? How many thousands— hundreds of thousands—died due to carcinogens in the cigarettes?

Ever hear of John D. MacArthur?

You have likely seen, read, heard, or been a recipient of a grant from the John D. and Catherine T. MacArthur Foundation. Maybe you've heard of MacArthur Genius Grants. You've seen the name on several public television programs and likely heard the name on NPR programming (National Public Radio). You can read all about MacArthur's success story on the foundation's website. When he died in 1978, John D. MacArthur was the third richest man in America.

How did this insurance mogul make his money? This tidbit from ABC News might offer a clue:

> Surviving the Depression...was likely due to John MacArthur's penchant for scamming customers, vendors, and investigators. He routinely discarded claims ("Heck, if someone really had a claim, he figured he would hear from him again") and misaddressed checks to keep money in the company coffers a bit longer.

What about the time MacArthur received positive press for hiring a diverse workforce? In actuality, according to his biography, the ceilings in his company's building were unusually low, so he hired little people at lower-than-low wages to be his custodians rather than spend money to bring the building up to code. It

appears the only reason he created his foundation was to escape all estate taxes—roughly a $6 billion tax dodge.

So let's ask the question a different way. Is accepting money from a liar, a thief, and an insurance scammer a problem? Or is it business as usual?

Is there a prevailing notion within nonprofit boardrooms to the effect of "Well, if we don't take that money, someone else will"—an idea that eschews ethics entirely?

I understand the logic of "We'll take everyone's money" and the logic of "We won't take any ethically impure money." Those are uncontaminated ideas. I may not agree with the former, but there's a pure logic to it. What I question is the efficacy of cherry-picking the ethics of the donors to your arts organization. Do you choose to receive or not to receive donations from particular corners of the philanthropic universe because of the nonprofit's core belief or your own personal core beliefs? Is your collective conscience bothered before you choose to accept the gift or after there's a public outcry about it?

Why you get up every morning is directly tied to your belief system. The question arises, then, that only you can answer: are you working for—or worse, running—a nonprofit arts organization that believes as you do, or are you convenient in your protestations when a horrible person or family wants to "arts-wash" their family name by making a sizable donation? ("Arts-wash" being a portmanteau of "arts" and "whitewash," whereby toxic donors attempt to hide old, bad acts by donating to a guileless nonprofit arts organization to clear their name.)

The above cases appear fairly cut-and-dried. Most of the toxic donorship cases for the nonprofit community fall closer to the gray areas where judgments are not so clear.

The Darla Moore case with the University of South Carolina fascinates me. On April 1, 2021, Darla's mother passed away at the age of 89. On April 5, Darla sent, according to Andy Shain of the *Columbia Post and Courier*, a "scathing letter" to

the university's board and administration. Why? Because they had not sent their sympathies for her mother's death four days earlier, a spate of time that happened to include Good Friday, a Saturday, and Easter Sunday.

What's fascinating about the case is that Darla, a $75 million donor, felt bad that she had not received any communication from the beneficiaries of her largesse less than 100 hours from the death of her parent.

The article continues with quotes from Darla's own letter.

"What did she [referring to herself in the third person] receive from the University of South Carolina, the recipient of the most exceptional generosity in the history of this state by virtue of her life? NOTHING."

"There is not a university in the country that would exhibit this degree of thoughtless, dismissive, and graceless ignorance of the death of a parent of their largest donor," Moore wrote. "I continue to be embarrassed and humiliated by my association with you and all you so disgracefully and incompetently display to the community you are charged to serve and to whom you look for support."

Let's look at the timeline for context. Let's also acknowledge the issues brought about by COVID-19, during the span of which this all took place. There will be more about COVID-19, this particular point in time, and its influence on the whole of the nonprofit community in a later chapter.

Lorraine Moore, mother of Darla Moore, died on Thursday, April 1, 2021. The president of the university, Bob Caslen, found out by reading an obituary on Good Friday, April 2, in the newspaper. Caslen was on a plane at the time, heading to San Antonio to support the women's basketball team, which had made the NCAA Final Four, and there were people pulling

at him from all sides during that trip, including dealing with COVID protocols throughout the journey. The Gamecocks lost to the Stanford Cardinal that night, 66–65.

On Saturday, April 3, the Moore family held the funeral. Caslen and the basketball team presumably flew back sometime that day.

Sunday, April 4 was Easter Sunday, a difficult day to contact anyone. Finally, on Monday, April 5, two letters were sent: a handwritten letter from Caslen to Moore and the aforementioned "scathing" letter from Moore to the university board and administration, a letter she allegedly leaked to the newspaper.

More context: Darla Moore did not want Bob Caslen to get the job as university president. On the day on which he was hired, Moore had sent a letter to the university's trustees to insist on reopening the hiring process, but was rejected out of hand. Additionally, and perhaps as a result of her actions, she and Caslen had evidently not spoken to each other for two years, according to reports.

Caslen made an error in judgment. Once he knew of the death on April 2, he should have tried to contact her (or at least her people) and, given his traveling issue, should have phoned, or at least had someone hand-deliver a dictated letter to her home. The complete breakdown in communication between the two people caused a great deal of this problem; it is the fault of both parties (not just the university) that this was allowed to happen.

With great responsibility comes great pride and giant egos.

Everyone is at fault here, but does the punishment fit the crime? Why was the death of the mother the tipping point?

Many development professionals and university leaders have trumpeted their support for the donor. Few have supported the university. Is that because they're trying to curry favor with their own donors? Or perhaps with Darla Moore herself?

Two opposing things can be true. The university board and Bob Caslen acted badly *and* Darla Moore acted badly. She

expected her money—*money that was no longer hers once donated*—to provide her with power, access, and undue influence on university affairs. The university, for example, canceled all bids in 2010 from architecture firms so that Darla Moore, the major donor for the new $90 million business school named after her, could choose her own design firm. The university spent $4 million on that firm, based in New York. Did that make her a toxic donor?

Was the cancellation of a bidding process policy a proper action for a public university? They broke no rules, but is that enough? Did the bidding process include local architecture firms who spent time and money on a bid? What about firms with Black or Latinx leaders—were they aced out of the process? Why did the university enable this kind of power grab?

Lots of questions. Not a lot of clean answers. The truth is, the faster the industry can relieve itself of its chosen responsibility to kowtow to toxic donors, the faster it can extend its value set. But the industry is made up of individual—and often, unscrupulous—organizations. Each one that accepts blood money, for lack of a better term, indicts the whole industry.

And while donor purity is impossible (donors are human beings, after all), if one organization seeks out tainted money, we all suffer the consequences of that action. The mistrust born from toxicity can (and almost always does) leach into the workings of organizations in the sector, causing leaders to have to explain their rationales in more and more detail.

Even the Good Donors Don't Know That You Run a Charity

Not all donors are toxic. In fact, fewer are toxic than you might think. The problem arises with simply one toxic donor's outrageous behavior. The public default opinion on nonprofit organizations is generally positive: 68% of those polled by YouGov related that they believed that charities improve

people's lives and are socially useful. It is the toxic, elitist, and deceitful people in the sector that have driven down confidence; only 52% of respondents trust charities.

In other words, people want to support charitable causes and some will do so *despite the fact that almost half don't trust that their money is being used properly.*

But the world of charities spins off the axis when discussing nonprofit arts organizations, especially in the United States. A small survey reported that, when asked whether a particular large arts organization was a charity or a commercial enterprise, more than half of respondents chose the latter. They knew that they were asked to donate, but they saw a difference in what a donation meant relative to a donation for a social service or social justice nonprofit.

Nonprofit arts organizations sometimes exist in a bubble, not unlike many specialty organizations. The bubble acts as a Cone of Silence (*à la* 1960s TV show *Get Smart*), in which most information, acclaim, and other data may be cacophonous to those in the organization, but rarely outside its walls. But the information that does escape the cone is so important.

Let's put it another way. Imagine you see someone walking the path around Seattle's Green Lake wearing basic sweats and sneakers. Ask that person what they think of a movie you've seen. They may answer in any way and it likely won't surprise you. Regardless of whether they loved, hated, or were indifferent toward it, it probably wouldn't affect how *you* felt about the movie.

Now imagine you're in the commissary of the studio at which the movie was made, having lunch. You come across the director of the movie, along with an actor who starred in it. You ask them what they thought of the movie.

If either or both of them tell you how dreadful it was, it will negatively affect how you felt about the movie. You'll be

inclined to hate the movie as well, *even if you already saw it and, at the time, liked it.*

Why?

Human nature. The perceived default for advocates of an organization or a project is wholly positive. That's the expectation. *Anything less than wholly positive* can destroy the reputation for that organization.

Board members, staff members, and anyone else attached to your organization are designated advocates. The public will expect every stakeholder to have the same opinion: unanimous love.

However, let's say you have 100 donors and 99 say nice things about your arts organization. The volume of the 99 will easily be drowned out by the 1 person who feels wronged and is loud about it. It's neither fair nor does it happen very much. But when it does, look out.

Quickie #2

The bulk of nonprofit donors give to you because they want your organization to succeed. Unless, of course, they're being hammerlocked to give because either their own business will suffer if they don't give (the organized crime treatment). Or they're being hammerlocked to give because the nonprofit has put together an emergency campaign in order to survive. That is nicknamed the Oral Roberts School of Fundraising, and it's the most devastatingly evil thing any nonprofit arts organization has ever done to its community.

Chapter 3

The Oral Roberts School of Fundraising

The Relationship between Measurable Impact and Finishing the Year in the Black

Here is a Venn diagram. The universe is all nonprofit arts organizations. The two subsets being compared and contrasted are Measurable Impact and Being in the Black.

A lot of work went into this carefully constructed diagram. As you can deduce, there is no connection between measurable impact and being in the black. None. Zero. Zip. Zilch.

But if it really came down to it, which bottom line is more important: impact or finance?

Let's imagine Dance Company A (DCA). No, it doesn't really exist. A month ago, DCA announced that they had only two months to raise $200,000 by hook or…well…the other way, in order to survive at least one more season. And, so far, they've raised $130,000 (or, at the very least, they *grossed* $130,000 at a fundraising brunch). But here's the rub: even with front-page coverage in the *Daily Planet*, it turns out that few people outside that swanky, "fabulous" brunch cared all that much about DCA. Maybe this lack of caring speaks to the near-death of the newspaper industry, Lois Lane's incomprehensible article on the subject, or the fact that Jimmy Olsen can't read. It turns out, however, that the campaign speaks to a glaring lack of data

showing the measurable impact of nonprofit arts groups overall in the Greater Metropolis region. Yet that didn't stop DCA from executing schemes like those first devised by the Oral Roberts School of Fundraising (ORSF).

Never heard of ORSF?

Its namesake was a hugely successful televangelist worth millions of dollars. Back in early 1987, Oral Roberts announced that he needed $8 million to train medical missionaries at his eponymous university medical school by April 1 (ironically, April Fool's Day) of that year, or, if not, "God will call me home." For good measure, he added that he'd hole up in his Tulsa, Oklahoma-based "prayer tower" until the money flowed.

Well, April Fool's! The money was never completely raised, Roberts died in 2009 at age 91, and by 1989 the medical school went bankrupt, leaving about $25 million in debt. (To which one wonders: Where did all that money go?)

So DCA—following the ORSF's pitiful lead—is basically holding a gun to its own head and saying, "Hey, Metropolis! Give us $200,000 or the dance company gets it!"

This tactic has been used several times in Seattle alone. ACT (A Contemporary Theatre) committed the largest offense of this kind of extortion, but it has also been done by several other organizations. And then, impudently, ACT did it again.

The short-term successes have been far outweighed by the long-term duress on the shoulders of ACT ("I just *gave* you a bunch of money—now you need more?"), other arts organizations during these campaigns ("I gave to ACT so I have no money left for you"), and a new trust deficit in the whole industry ("If I give you money, how do I know you won't just close anyway and pocket it?"). Other companies in Seattle have had to battle bad reputations that weren't even their own, just so ACT wouldn't close its doors—as though institutional survival were the mission of a financially broken organization...*as though*

institutional survival outweighed community impact by all nonprofit arts organizations in the area.

When I asked a prominent stakeholder for ACT whether they were aware of the negative effect that their ORSF campaign had had on the entire arts community in Seattle, the response was unbelievably cynical and cold-blooded: "My theater was about to go out of business and we needed the money. My job has nothing to do with the rest of the community."

In other words, "I don't care if every other nonprofit arts organization closes down, as long as mine doesn't."

Can you imagine a board member of a nonprofit food bank or homeless shelter saying that about every social service charity in the region?

This is what I say to that stakeholder from ACT: *so what* if your theater closes down? I wish yours had. And so do dozens of other arts organizations in Seattle that, because of your self-indulgence, have had to scramble even harder to make ends meet.

Every single show that has ever been on Broadway has closed, except for the ones that are open right now. Closing, therefore, is clearly not an act of failure, just an inescapable reality.

If one show—even in a commercial environment—found a way to survive at the expense of every other show, however, then that *would* be a desperate failure. Thus, when a nonprofit arts organization chooses its own survival over the greater needs of its community, it causes a death-inducing funding vacuum that adversely affects all of the other arts organizations. It sows widespread mistrust and excuses mismanagement. It is, in fact, an inconceivably selfish and venal act—one unworthy of support. It is an act of desperate failure when the moment calls for an act of grace.

Let's imagine, for example, that those using ORSF to fundraise for ACT could have seen the survival-at-all-costs-including-the-deaths-of-other-local-organizations scenario they'd written for themselves. Let's imagine, as a response, that they chose, as a final act of grace, to fundraise instead for other arts organizations—ones that are creating a positive, measurable impact for the community.

I know. It might be a stretch to see how selflessly a nonprofit arts organization can behave when survival is at stake. Or even when it isn't.

In 2021, I ran into Scott Nolte, the now-retired co-founder of the Taproot Theatre Company in the Greenwood section of Seattle. Here's its mission statement:

> Taproot Theatre Company creates theater experiences to brighten the spirit, engage the mind and deepen the understanding of the world around us while inspiring imagination, conversation, and hope.

The mission statement is humble, almost hesitant, and not necessarily quantifiable, but Taproot has focused for more than 40 years on providing positive spirit for people. This separates them from the larger Seattle arts organizations, many of whom cling to the old-fashioned notion that plays must be pretty first, effective second, and as far as measurable impact goes—well, if they get to it.

"There's no question that we need financial discipline, and keen sales and fundraising skills, or we're rapidly out of business," said Nolte. "However, our 501(c)(3) status expects us to work for the common good, not profitability or personal gain. I'm a proponent of the triad metric of success: artistic merit, financial stability, and mission consistency. They need to be linked. It may not take hyper-smart plays to meet those metrics.

Recently, a woman in chemotherapy at the Fred Hutchinson Cancer Research Center attended a comedy here with a free ticket and wrote to tell us how much she just needed to laugh. If we explain the goals and describe who's being impacted, and invite people to accomplish their aspirations through us, we expect to reap and retain long-term donors who are thrilled to give."

Am I saying that Taproot deserves funding because it is a nonprofit providing measurable impact on societal issues and, oh by the way, also happens to produce art? Of course I am.

Am I also saying that arts organizations that focus their impact internally in order to produce "good art" (an awfully subjective phrase) with little intention of doing community good ought not to be nonprofit in the first place? And therefore, they may not be deserving of your support?

Maybe.

If you're looking for someone to remind you why your nonprofit arts organization matters, for God's sake (literally) don't ask any descendant of Oral Roberts. Ask Scott Nolte. He's more in tune with the divine than millionaire preachers in designer suits, no matter how religious they say they are.

Chapter 4

He Who Serves Two Masters Has to Lie to One

"Moo"

Having morals and values tends to dampen your company's ability to raise money from nogoodniks.

As it should.

Remembering, of course, that nogoodniks do not believe that they are nogoodniks (and nogoodnik is a subjective term; some nogoodniks might be more "goodnik" than others), your financial support has to come from somewhere. Part of the reason your organization may have issues raising money is the fact that you have a strong earned-revenue stream. After all, if your ticket sales are more important than any impact you might make in your community, why should a community foundation support you? Why not just sell more tickets?

Several years ago, I consulted for a company in the mid-Atlantic region of the United States. As part of the nonprofit arts universe in its area, it was best known for producing new plays by local playwrights, or for producing new and contemporary plays by national playwrights telling a story local to the region.

And every Christmas, it produced Charles Dickens' *A Christmas Carol*, adapted by a local artist who donated his royalties back to the company each year. He believed that, because most of the play came verbatim from the book (except for the deletion of several scenes to keep it at 90 minutes), he "didn't have the right to get paid for someone else's work."

Noble.

During the consultation, it was obvious why they produced *A Christmas Carol*. The engagement would sell approximately 90% of its available tickets each year, at a premium price. The

audiences were mostly the same every year—non-subscribers who brought their extended families during the school holiday weeks.

Ballet companies do *The Nutcracker*. Symphonies do Handel's *Messiah*. Theaters do *A Christmas Carol*.

Knowing this, sponsors lined up to support this production. These were the sponsors who were loath to support the theater's core activities, new plays that might (or might not) cause controversy. The company's reputation, while good in artistic quality, was sadly that of a company that had few to no inroads into the neediest within the community, instead focusing on big-money donors and audience members.

I wish this were unusual, but it is more common that you might imagine. There are more nonprofit arts organizations in America that believe they are *arts organizations that happen to be nonprofit* than there are those that believe they are *nonprofit organizations that use the arts as a tool to better the community*. The former is easier to do, but the latter is easier to support.

And, as stated before, "size doesn't matter." This organization, while not large, had no less a duty to serve its community than larger ones, smaller ones, and those approximating its size. In a perfect charitable world (and this is the case with most nonprofit organizations), the only difference between a small organization and a large one is the scope of underserved people that can be helped. Large nonprofits serve large communities of the people needing help, perhaps in large swaths of support; small ones serve smaller communities, perhaps more targeted ones.

In any case, in the year previous to my consultation, the company faced a funding crisis. Two major foundations in the area which, together, had granted $500,000 to the company in the previous cycle asked questions they had never asked. The foundations' budgets had been cut (result of the 2008–2010 recession) by a goodly amount and they were looking to see

where they might cut some funding in order to assert themselves more surgically.

During the interview process with the artistic director and the board chair, the question came up about doing new plays as a core value—it was even mentioned in their mission—and doing *A Christmas Carol*. The question was simple, and the answer was baldly truthful.

"Why do you produce *A Christmas Carol*? It's neither new nor contemporary. It doesn't seem to fit with the rest of your programming."

"Because it's a cash cow. We do it to raise enough money to afford the rest of the season. And besides, the families in town love it."

Moo.

Here was the foundations' takeaway: they zeroed out their funding for the nonprofit.

Why?

Because even though they studied the nonprofit's books, they were told by both leaders that the company chose to produce a work outside their mission in order to pay the bills. And the success of that project allowed them to believe that they didn't *need* the additional support of their foundation dollars, especially in a year where other, more direct support was needed to house, feed, and clothe people during a recession.

When the company breached the mission, it breached its responsibility to new writers and stories of the region, according to the two foundations. If that nonprofit chose to contravene its mission just to make money, then it didn't need foundation dollars to support it on top of that.

I'd never heard of a foundation choosing to punish a company for producing a cash cow, however mad that cow was, but the logic of their reasoning was impeccable, despite the protestations of the company's leaders.

Working quickly, it was determined that the company needed both funding streams in order to do its work properly: foundations and *A Christmas Carol*. But accepting one stream necessarily cut off the other. "The No-Win Scenario," to be sure.

So I creatively assisted the company to challenge the dilemma.

A nonprofit may be exempt from taxes on income having to do with its mission. Unrelated business (and there are a slew of examples) is taxable at the corporate tax rate in the state. But tax-exempt income is allowable not only in ticket sales and concessions sold during the performance, but in rights, rents, and royalties.

The company could legitimately have *someone else* produce *A Christmas Carol* during the same time slot and pay rent for the privilege. If that someone else produced a commercial production, it would not threaten the nonprofit status of the company (just like a nonprofit theater building presenting the national tour of *Hamilton*!).

What made it more creative is that a few board members—with full disclosure as potential conflicts of interest, both in contract and submitted to the auditors for approval—put together a company whose sole business was producing *A Christmas Carol*. And they sold shares of the production, legally, to investors. These investors included two of the former corporate sponsors.

After all the expenses, the profits were donated by the commercial enterprise to the nonprofit theater company. The profits were only slightly less (because of corporate taxes) than they would have been had the theater itself produced the play. But the upshot of all of it was that *A Christmas Carol* played in the same dates and space as it always had, the audience (which, to repeat, in the main, did not buy tickets to any other production presented by that theater) saw no difference, and the foundations came back one year later with 50% of the support from two years past: $250,000.

Things were still tight, but now there was a framework on how to dance that particular foxtrot. With the help of local attorneys familiar with state laws on the manner in which nonprofits can operate, this company was able to legally state its longstanding intentions of producing new works, while not jeopardizing some of the revenue derived from a "one-of-these-things-is-not-like-the-other" one-off production of *A Christmas Carol*.

Unfortunately for everyone in the area, that company closed its doors less than a year into the 2020 pandemic. No amount of federal or state subsidies were going to be enough to allow it to continue. However—*and this is usually what happens*—another arts organization now occupies the same theater space.

Big Donations from a Few or Smaller Donations from a Bunch?

The one thing that little arrangement did not solve was this: how do you serve two masters?

Honestly, you can't.

Revenue for nonprofit arts organizations is a bear. It's a losing battle in so many ways. For many, there are endless confabs with corporate America. And as much as arts organizations are comprised of dream-weaving, liberal, generous (which, if you check your Funk & Wagnalls, is synonymous to liberal), anti-racist, anti-discriminatory artists and leaders, major donors are more often Republicans than Democrats.

In a Zogby poll in 2003, the results showed that 31% of Republicans gave more than $1,000 apiece to charity, while only 17% of Democrats gave at that level. More Democrats than Republicans gave less than $99 by a rate of 35% vs. 19%, but that did not make up the difference. Incidentally, those who represented themselves as Independent gave even less than their counterparts in both parties. You can infer what you'd like out of that.

That all makes some sense, at least to this liberally minded soul. The Democratic mindset believes in thousands of small donors. President Joe Biden talked about the size of the donations as a badge of honor to other Democrats. In August 2020, just before the general election, he announced with some pride: "We have over 1.6 million people who contributed in the middle of this economic crisis, somewhere between \$5, \$10, \$15. I'd say that shows some genuine enthusiasm about making sure we have a chance at becoming president of the United States."

And there was enthusiasm. And he won, despite what any dangerous lunatic might tell you.

Left-leaning individuals generally believe in the power of a diverse and large number of people to achieve greatness, or at the very least to solve the issues of the world. For them, the best situation is one in which obligation is to a wider swath of the public, ensuring a greater good and less gratuity to a "1%" class. Government (i.e., "We, the People") can provide more bang, more bucks, and a healthier society. Their ideal model: a lot of people giving a few dollars.

Do not mistake this as liberals not being generous with their wealth. Many are.

Liberals in America staunchly support, for example, universal healthcare. They see 95% of other developed countries using it. They've noted that the average age of death in the US is just over 73 (and going down), while in Canada, where universal healthcare exists, the average life expectancy is 82 (and going up). And while there are mitigating factors to life expectancy in the US (the most egregious of which is gun murder, both homicidal and suicidal: 12.21 gun deaths per 100,000 people in the US; 2.05 in Canada), liberals believe that if we all paid a little more in tax to a universal healthcare system, where there are no bills and no reason to choose between rent and medical care, the US would be healthier. In doing so, the price of health insurance wouldn't be passed on to business owners and competing

insurance services who look at insurance payouts as a "loss" while their CEOs reap billions in salary and bonuses. Business expenses would decrease.

Right-leaning individuals generally believe in the power of individuals to achieve a greater good, or at the very least to solve the most pressing issues in their world. For them, the best situation is one in which their gift to a nonprofit achieves a shared spotlight on success. Government (i.e., "Those People") does not provide relief; it provides chaos. Their ideal model: a few people giving a lot of dollars.

Do not mistake this as conservatives being generous with their wealth. Many are not.

So then it is no surprise that nonprofit arts organizations (especially those in the performing arts)—the individual cases for which have usually not provided quantifiable, tangible impact on a social need in their communities, but rather a woolgathering vision of production excellence, collaborative training, ad hoc arts education, or worst of all, the "nurturing of the soul"—are more heavily supported by right-leaning individuals and corporate dollars. The way in which arts organizations are set up is part of the issue here, especially in large organizations. A single board member or donor can wield more influence over the work of that nonprofit, regardless of how many people work there or are ostensibly served.

The relationship between major donors and the arts is one that goes back to patronage. They're even called "patrons of the arts," as though they were modern-day Medicis. Today, arts patrons are no less powerful than they were during the Renaissance. When a major donor or foundation leader calls, artists listen. When they don't listen, they often get figuratively decapitated.

Paradoxically, a majority of nonprofit arts organizations judge their primary value by the sale of tickets, just as their for-profit brethren do. Ticket sales are easy guideposts to measuring

popularity. Popularity feels good. It may have nothing to do with the mission of the organization, but it feels good.

That's the murky chunk, of course. People buy tickets because they want to see a performance and rate that transaction by that experience. People donate because they want to manage/share in/support what the company does. Those that choose to donate large amounts to a select few organizations—the conservatives' vantage point described above—gain power in that kind of relationship.

There are some artistic directors who hate raising money so much that they would gladly give up contributed income if they possibly could. They are much more comfortable in a world where a lot of people give small amounts because the power in that kind of relationship goes to them.

Ticket sales offer exactly that—a lot of people giving a few dollars.

Major gifts offer the opposite—a few people giving a lot of dollars.

Two masters: the ticket-buyer and the major donor. One servant: the arts organization.

All of the foregoing in this chapter was a long walk to these propositions:

What if your nonprofit arts organization were forced, for whatever reason, to choose between two production options: a) an artistically lesser event that had the opportunity to raise awareness and dollars to charities that feed hungry people; or b) a star-led on-stage event that had nothing to do with the company's stated mission but was likely to go to Broadway after its tryout run on your stage? Further, what if it had already committed to doing the former when the latter opportunity falls into its lap, but it meant that it couldn't do both?

Before you answer, "Why not do both?" consider that these kinds of binary choices come up all the time. And the premise of the question was that you *couldn't* do both.

What if the donor whose name is on your building is rightfully imprisoned? What if that donor isn't imprisoned, but is merely morally corrupt? What if that donor did nothing either illegal or corrupt, but the family of that person—and hence the name on the building—committed atrocities on unsuspecting victims?

What if the event at your building is so unexpectedly popular that it has become a sensation and you have the opportunity to (and there's an audience for) extending the event for ten weeks, but that would mean that the next event—an event that serves your DEI initiatives—would be postponed until another season, or, likelier, cancelled. What if that first event is completely Eurocentric (white) in nature? And what if there is no other facility in which to move the first event *or* the second event?

What if your nonprofit organization chose as its primary goal the elimination of a societal problem, using its art as a tool to do so? How would that even work?

Doing the Right Thing Is the Right Thing to Do

As a preamble, let's accept that in order for nonprofit arts organizations to flourish in this "next normal," there are some new truths to the sector.

Part of those truths emanates from a newfound impulse for modern organizations to incorporate DEI values into their work. Some of it is from a white point of view, which leads to unintentionally insulting utterances such as "diversity is good for business." If you've uttered these words, you probably should be wincing about now.

Why should you be wincing?

Because of this:

Raising levels of diversity, equity, and inclusion is simply the right thing to do. Even if it were seen as somehow bad for business, it would STILL be the right thing to do.

Saying that "diversity is good for business" monetizes the Black community. Monetizing the Black community is a sensitive issue. After all, slavery monetized the Black community. Owning slaves was good for industry, too, for a bunch of white farmers and businessmen. There are those who would welcome the return to that way of life. They can be found at any Klan rally or capitol insurrection. Check your local listings for one near you.

We'll be talking more about this in Chapter 5. But for now, it's important to know that your impulse toward equity is a correct one. See how it fits into the "two masters" problem.

You may not realize that the connection between "well-meaning white person" and "racist insurrectionist" is direct, but it is. That said, the connection between "well-meaning white person" and "using your personal toolbox to raise awareness and eliminate social, financial, and trust disparities between Black people and white people" runs a shorter distance and is obviously more fruitful. It's just a slippery uphill climb and takes more effort.

The impulse to look at one's company with the notion that DEI is just the right thing to do is a valid one. Serving that important work necessitates burying forever other work that your nonprofit arts organization may have been doing for years. Doing right in your region definitively means that your art must change from its white roots. It is not a "both/and" proposition; it's a "this not that" reality. However, it might even take money out of your coffers, at least at first.

These are two masters that cannot be served equally when the diversity portion is an add-on, regardless of any spurious diversity manifesto that your organization put on its website just after George Floyd was killed.

In the United States, the post-George Floyd era marked the amplification (not the beginning, just an increased volume) of a sharply divided country in which people choose to listen

only to one side of any story regardless of its actual truth (or lack thereof).

The US is already a "house divided against itself," as Lincoln put it. He was right. It cannot stand. In fact, it did not stand. Not in the mid-1800s. Not in the late 1700s. And not now.

Figuratively speaking, the US's house was built as a segregated duplex with a deeply cracked foundation called "slavery," expanded into increasingly segregated multi-family apartments with more cracked foundations, and is now a teetering, thousand-story high-rise with the über-wealthy 1% occupying the top 750 floors, the next 30% occupying the next 200 floors down, the next 60% occupying the lowest 50 floors, and the rest sleeping on the sidewalk in cardboard boxes.

The arts have been there since the first cave drawing. The first time someone noticed that hitting one rock against another produced a certain tone. The first time someone danced because it finally rained (or finally stopped raining).

Recently, Jill Robinson, the CEO of TRG Arts—perhaps the leading knowledge provider and consulting group in the United States and the United Kingdom—wrote an article that discussed what live performance organizations—mostly nonprofit—have to consider in this COVID-plagued, DEI-infused twenty-first century. Jill's power emanates from her broad knowledge base and ability to look beyond "what is" and envision the best and worst of "what might be."

If our objective is to create programs that appeal to new and diverse audiences, well...is that really happening? It IS possible to create positive change, no matter the business model...Inventory and access are where the rubber hits the road, and I see few leaders willing to disrupt the status quo with existing loyalists to enable access for the broader community. CEOs and boards talk about wanting to engage different, broader communities, but do inventory or event

access practices follow? Whether desired new participants are of a different age or race, in a different geography or some other demographic group, our actions say EVERYTHING about our commitment.

One word that shuts off the idea of "enabling access for the broader community" faster than a 200-amp fuse in a 15-amp socket is "appeal." It is the bugaboo of all nonprofits with missions to make a better world, and used in so many insidious ways as to be detrimental. To enact real change, please remove "appeal" from your organizational vocabulary. An "appeal" is something you use when you expect the answer will be no. In effect, it puts the nonprofit in a position of weakness.

"Appeal," as Jill's paragraph implies, has to do with creating art that will be liked, enjoyed, and loved by a blob of protoplasm called "the audience." To many arts leaders, it is a genuflective response, guessing at what will be popular rather than choosing to create an environment of support that reflects an idealized society (rather than merely an entertained one). At what point can we grow up and reflect *all* our hopes and dreams, rather than those of the traditional, white, moneyed donor/audience?

"Appeal" also refers to development documents. "Please give us money because we're really good at producing art" is an appeal that is often proffered and rarely works.

If you only list the artistic achievements of the company, you will only reach those for whom that matters; again, the traditional, white, moneyed donor/audience. Rather than issue an appeal, just communicate regularly with your stakeholders. Even the ones who do not donate. Even the ones who have never set foot in your building. Talk to them about the specific impacts the organization has made and why everyone in the community is better off for your organization's work. Most importantly, listen to the priorities they champion to make the community better. Address those.

And above all—this is critical—do not make every communication a fundraising letter. It diminishes everything else on your storytelling and just becomes a commercial. Or a student at a televised college football game holding a sign that says, "Hi Dad! Send Money!"

Finally, "appeal" is a verb, usually used in a legal sense, asking for a higher court to overrule a decision. In this case, nonprofit arts leaders have to stop dragging their feet by using the old, dusty argument that some of the staunchest financial supporters don't want change. Change has happened. It will continue to happen. Stop attempting to make that tired argument against charitable organization impact (and instead, for pretty entertainments) by referencing the higher court of toxic donors.

Why You Should Fire Your Artistic Director

Artistic directors should not act as the face of arts companies. It's an awkward relic from long ago and it might be keeping your organization from succeeding as a charity.

There is a better way.

If you run an arts organization that happens to be a nonprofit just so that you can reap donations, you're going to hate this.

If you serve on the board of a nonprofit organization that uses art as a tool to make quantifiable positive changes to members of the community who require it, you're going to be relieved.

And if you're an artistic director of an arts organization, whether you've been there for a week or 30 years, there is a great "pivot" in your future, to use the hackneyed COVID-era business word.

If arts organizations are to succeed, they must prove worth. Not artistically—that's a given. Not with a ridiculous word such as "excellence," because that's subjective and worthless. The person best positioned to prove worth to a community is neither an artistic nor a managing director.

It is a single executive director, to whom the artistic officer (and marketing officer, finance officer, operations officer, development officer and production officer, etc.) reports. This differs from the idea of a "producing artistic director," whose job is more dependent on the execution of art than an executive director.

Visions cannot change willy-nilly every time a new artistic leader comes aboard. When they do, they negate the entirety of the past of the organization as being just another fluffball, a vanity company.

Check your vision on the next page.

V

I S I O N

DOESNOTCHANGE

JUSTBECAUSELEADERSCHANGE

UNLESSYOURVISIONISBLURRYORUNNECESSARY

WHICHIFTHATISTHECASEMEANSYOUSHOULDCLOSEYOURDOORS

For-profit? Do whatever you want that makes money or satisfies your artistic itch. The producer will rein you in when necessary.

But nonprofit? You never hear about "culinary directors" of food banks deciding which foods will feed their people by some sort of academic vision of cauliflower and pork rinds.

Boards: *it's time to fire your artistic director*, no matter how much you like them.

Wish them well. Strategize the severance so that the other artists in the community are not surprised or inclined to revolt. Resist the temptation to merely demote—it's a cancer waiting to happen.

Instead, hire a new artist to an officer-level position. Pay all of your officers the same salary. This is the pay equity portion of the new normal that everyone's been talking about. And make sure that your staff not only represents the people in your community, but highlights the cultural differences among you. We'll talk more about that in Chapter 5.

Then let the executive director work with the board to do activities that help your community rise. That executive director's job, in essence, is to make sure the mission is the reason for every decision, every activity, and every work of art.

No. Matter. What.

It is not as though an artistic director cannot do these things. But when an artistic director's job is split, it guarantees that at some points, there will necessarily be a gap between leadership on mission execution and leadership in the particular art pieces being produced. Also, when they are in the process of directing a particular artistic piece, they become absent leaders, almost as though they are on vacation for weeks at a time. Or worse, appearing to do something they'd *rather do* than lead a whole nonprofit organization.

If you're puzzled by this idea, don't be.

The ringmaster, for example, doesn't run the circus.

Neither does an astronaut run a space flight.

And an artistic director should never be the leader—titular or otherwise—of any nonprofit arts organization. Their job is to design the artistic programs under the aegis of the executive director's control of the mission, which is to make their community a better place.

It also saves the nonprofit from a fundamental "two masters" problem. In an organization run by an executive director and the board, there is only one master: the mission. Not simply revenue or balance sheets or financial implications. The mission, if it is a good one, is the boss; everyone is there to serve that one master.

If "Butts in Seats" Were a Metric of Success, then the Yankees Would Be a Nonprofit

Another irreconcilable issue that causes the "two masters" problem is the sale of tickets. This is not to suggest that ticket sales are illegal or even illegitimate ways to grow revenue. Earned revenue—income derived from a transactional relationship with a buyer in which the nonprofit arts organization produces its work—is a totally reasonable way to enhance revenue.

Or is it?

When an organization determines that its metrics for success are headlined by ticket sales—butts in seats, if you will—it has announced to the world that it has modeled itself after a commercial model (Broadway theater, Ringling Brothers, etc.) and only acts as a charity for contributions received, not impact provided.

It uses the executive director position as an impresario—someone seeking fame for the company (and self)—rather than as a community leader. A community leader seeks to help those who need help. It's the difference between self-facing renown and outward-facing impact.

To an impresario, the source of the income does not matter, as long as it comes. There have been countless tales of ways to earn more income from a company, even if the product is lousy.

We tend to lionize these impresarios, from Phineas T. Barnum to Garth Drabinsky, even when they break the law. Or we laugh at their antics, despite the desperation from which they were founded.

There's the story of the notorious Broadway producer David Merrick and his production of *Subways Are For Sleeping*, which garnered mostly negative reviews when it opened in 1961. The show had been languishing at the box office when an ad ran in the *New York Herald-Tribune* with outstanding quotes from Howard Taubman, Walter Kerr, John Chapman, Richard Watts, Norman Nadel, and Robert Coleman.

The ad implied that the major newspaper writers of the era had said wonderful things about *Subways Are For Sleeping*. After all, Howard Taubman, Walter Kerr, John Chapman, Richard Watts, Norman Nadel, and Robert Coleman were major theater critics in the New York media. However, if you were to have looked closer at the ad, you would have noticed that their respective publications were never mentioned. Why? Because these people named Howard Taubman, Walter Kerr, John Chapman, Richard Watts, Norman Nadel, and Robert Coleman were identically named people whom David Merrick found in a New York City phone directory. The tale goes that Merrick allegedly wined, dined, provided limousine service and hotel rooms, and paid cash money to these fortunately named people and asked them to sign on to quotes he wrote himself. They wrote quotes like: "One of the few great musical comedies of the last thirty years, one of the best of our time!" (Howard Taubman) and "What a show! What a show! What a solid hit! If you want to be overjoyed, spend an evening with 'Subways Are For Sleeping.' A triumph!" (Walter Kerr).

That's show biz.

Nonprofit organizations—even arts organizations—run a business, too. Unlike David Merrick, they don't run these

organizations for money. They run it for impact. Or at least they're supposed to.

No one on the board of a homeless shelter looks at the financial bottom line for success, just for sustainability. Their job is to ask:

How many people were housed? How well? Were qualified people left out? Why? What happened to the people after they were housed? Are they still coming? Are the numbers increasing? Can we handle the increase?

And then, after all that:

How do we pay for all this?

Meanwhile, arts organization boards ask these questions:

Are people coming? Why or why not? Did the event get good reviews? What did the critics say? How much ticket money is coming in? What did you expect to come in?

And then, after all that:

How much money are we going to have to give or get in order to make the revenue goals?

Ticket sales, believe it or not, are irrelevant. Organizations hemmed in by a financial model in which ticket sales determine success and failure have been hammer-thrown into Olympian disarray by the pandemic and subsequent social justice requirements. Looking at ticket sales first and filling in donations afterwards may be keeping the entire nonprofit arts community from thriving.

What if nonprofit arts organizations chose to run like the nonprofit service organizations that they were intended to become? How do we get to the part where boards ask about the welfare of the people served rather than the financial results of the latest production/event/exhibition?

What if they happen to engage in the arts in order to fulfill a societal need? What if they acted like a refugee protection society instead of a racetrack? What would that look like?

We'll be talking about companies doing exactly that throughout the book and have some ideas for you in Chapter 9. *But don't look ahead.* If you're not convinced that your nonprofit arts organization has to change from an arts-first perspective to an impact-first perspective, you're not ready for that chapter.

Stop Using Revenue as a Goal for Your Development Department; Relationships Are All That Matter

You should recognize that in this newly socially aware community, if you are depending on your executive director or development director to be the key fundraisers to your organization, you're failing.

Stop thinking that your organization "just needs to get some grant money." Grants are minor and can be handled by the professionals on your staff.

In the same vein, you cannot judge your executive staff on how much money they raise. That may have been a metric years ago, but it hasn't been for quite a while. A long while.

A good development director who has been keeping up with the industry will tell you flat out that developing relationships leads to raised money. When asked for money too quickly— an inevitable action when the development director is simply judged on how much money was received—a donor might well react in the same manner as a marriage proposal on the first date. Disgusted, surprised, and taken aback.

The metric of "money raised" causes harm in such situations. The correct metric, then, should be the number of new relationships, not the amount of money. If you develop the first, you raise the second.

Another harm caused by money as a metric of success can be the offering of unethical benefits to current donors in order to get them to renew their support.

In January 2021, as the COVID-19 vaccines just started rolling out, there was not enough to meet demand. As you might

imagine, there were important safeguards put in to ensure that the neediest—those with the highest probability of becoming infected and dying—were first in line.

Unless you were a donor of the Overlake Medical Center & Clinics in ritzy and sterile Bellevue, Washington. Molly Stearns, the chief development officer of the nonprofit, emailed 110 substantial donors informing them that they would receive special appointment slots to get their shots.

"Dear Overlake major donors," the email began (so impersonal, but that's par for the course for this department, evidently). "We're pleased to share that we have 500 new open appointments in the Overlake COVID-19 vaccine clinic, beginning this afternoon [Friday, January 22, 2021] and tomorrow and next week."

Because there is a political nature to these things, it is important to present the receipts of wrongdoing. Molly Stearns was the chief development officer. The president and CEO was J. Michael Marsh. *Surprisingly, both were still gainfully employed by the organization, at least as of this writing.* One would have hoped that the ethics of Overlake and its august Board of Trustees might have done something about that.

Despite all the business classes, Ted Talks, and case studies about what to do when one royally screws up, Marsh's instinct was to wait it out until the drumbeat faded. And when his board did nothing (ostensibly because the lack of ethics extended to them, as they received the email as well), it proved allegedly corrupt behavior on the part of Overlake.

Why does this happen?

It's all about that "two masters" thing, once again. Serving the community and serving the big donors broke down the integrity of Overlake like a spatchcocked chicken.

Before you get all comfy, self-righteous, and condemnatory, with your tongue against your front teeth in anticipation of its first of many "tsks," just know that this is probably happening at your nonprofit arts organization, too.

If your nonprofit provides a tangible perk as a return on donation investment—no matter how trifling—then you are just as unethical as Overlake Medical Center, Molly Stearns, and J. Michael Marsh were. Regardless of the popularity or preciousness of that perk, ethics draws a line in the sand. Even a dollar's worth of benefit is a dollar over the line.

Does your nonprofit arts organization have a series of perks based on how much is donated, like the previous lists from the Detroit Opera House and the San Francisco Symphony in Chapter 2?

It doesn't take preferred access to a life-saving virus to prove unethical behavior. Unethical is unethical. Believing that ethics has a dollar figure attached to it confirms the bad act.

There's an old story about that line of demarcation. Its true origin—if it even has a true origin—is unknown. Its first variation (1937) attributed the story to a Lord Beaverbrook.

No, I didn't make that name up.

They are telling this of Lord Beaverbrook and a visiting Yankee actress. In a game of hypothetical questions, Beaverbrook asked the lady: "Would you live with a stranger if he paid you one million pounds?" She said she would. "And if he paid you five pounds?" The irate lady fumed: "Five pounds. What do you think I am?" Beaverbrook replied: "We've already established that. Now we are trying to determine the degree."

—O. O. McIntyre

Unethical behavior, no matter the price, is equivalent to a world leader announcing, during a white supremacist riot, that "there are good people—on both sides."

Perhaps the saddest part of this whole entanglement is that perks are completely tangential to the choice of making a donation.

You don't have to act this way. All you have to do is to stop using revenue as a metric for success for your development department.

Using cash revenues as a metric to quantify an employee's success causes dangerously evil, unethical behavior. When cash is king, everyone suffers—especially your community. It happened at Overlake and it's happening to you. It is the soul-sucking, damaging, termination-worthy result of artistic vision that has no relevance except for its own aggrandizement. Large arts organizations nationwide—we're especially looking at YOU.

If the social justice movement has taught us nothing else, it has taught nonprofits to look at their community impact through the eyes of the underserved users, not the eyes of the donors.

Let's take this moment in time to help you get out of the dangerous, idiotic, sycophantic cycle you might be on. First and foremost...

The development sequence includes a slew of steps before any money changes hands. "Fundraising" is just one step of the sequence, near the end, right before "thank you" and "follow-up." It's a step far down the line, after introductions, engagement, research, etc.

Developing a joy for your company's impact is a way to share the good news of the company, just as you would share a personal review of a great restaurant. Your inspired behavior should inspire others. Life is too short to let bad companies suck all the money out of the community because they have a special private reception hall for big donors. Yours is a nonprofit organization with a mission to help people, not a casino with a mission to fleece people.

Don't measure your development efforts by how much cash is brought in. Instead, ask "How many donor connections are in the cycle?"

It's not about the money—it's about the connections. Like the liberally minded Americans mentioned earlier, an organization garners more power when it makes millions of connections that ultimately give $10 than a single connection that gives $1,000,000.

Each year, more donors should be in the process, somewhere, and your development directors should be able to tell you exactly where they are. This applies to individuals, foundations, and corporate donors—but especially to individuals. And remember that some may never give a dime, but it's likely not because of your development director.

The easiest first metric to examine, for any nonprofit arts organization, is this:

How many donors (or prospective donors) give to the organization just because it is impactful—and for no other reason?

These would be households that give with no obvious personal connection. They are not board members (past or present), employees (past or present), parents of participants, artists, or people sitting at a table at your gala as the guest of one of your board members. They might know some of the players in your organization, but that's not why they chose to give (even a small amount). If you have a lot of those, you're in good shape. If not, you're not.

After that, belay some of that ill-conceived talk of donor-centric organizations. The idea—that donors should be advised of everything the organization does for the sake of transparency and buy-in—has been corrupted by nonprofits who only show the organization's good side. When donors' wishes are at the top of the charity agenda, donors only fund what they can see, leading to overfunding of showy programs and underfunding of overhead. In the long run, donors are only important in that

they can make other people's lives better. They're not important enough to cut in line at the vaccination center.

I heard that. No, they're not.

Anyway, your development staff can put together a personal connections plan for your board members on a reasonable list of donors who might be able to help. To develop them as significant donors, they must gain a connection with the organization, even if they are on your core list of "donors with no connections." That connection has to be a human being. After all, you can't just ask Bill Gates for money if you don't know Bill Gates and where he stands on your issues. Would you give a large sum of money to a stranger? Hardly.

No matter what your role is at your nonprofit arts organization, when you have a connection, it is your responsibility—your crucial responsibility—to honor that connection by zealously finding a way to create a positive relationship. Not with the doe-eyed look of a person about to ask for money. Because...

For the sake of all that is holy, do not ask that person for money yet. That's called "begging" and it doesn't go over well for anyone.

If your development staff believes the prospect of a gift is real, they will let you know the next steps. But even if it's not real, continue to stay in touch with your connection. Don't pass them off to your executive director or development director as though they were batons in a relay race. They may never want to donate to your company, but they might know someone who will. Talk to them, you know, like people.

Don't play with your prospects as though it were a game. It's not a game. It's your job, regardless of whether you're a staff member, board member, or other stakeholder.

After qualifying your prospect, let that person know exactly when you'll be asking for a gift. Literally. "We'll be asking you

for a gift in six months. In the meantime, we want to share some news about our work."

Then do just that. No asks, just info. Awards, impact numbers, true stories, etc. Take time to see what excites your connection to give; don't force a program on them.

Then, a week before you said you'd ask, assuming you've had conversations, letters, emails, texts, and other assorted contacts with the prospective donor, let them know that you're going to see them next week about a gift. By then, you should have done the research and know exactly how much they should be able to give, how much they've given to others, and any other obstacles to the gift should have been minimized by having a real relationship with that person.

Whether they give at the level you expect or not, stay in touch. Forever and ever. And when they're comfortable, ask if they know anyone with whom they can share their zealous support.

And that's how you do it. No magic. Just relationships and information. But this, and this alone, is the most crucial responsibility to board membership. Raise funds. Ensure support.

You've heard it many times: you have to date before you get married. But more than that, for a successful marriage, you have to put in the time and effort to enjoy your similarities and differences, your likes and dislikes, your tenets and culture. Otherwise, why bother?

The Art You Produce Is Not in Service to Your Community

Art is a tool. It is a means to an end. It is not the end product.

If you believe that statement is incorrect, then...

Blow it up.

Art itself is a good thing. But to qualify as a nonprofit, you have to prove that *your* nonprofit's art has made *your* community a better place and that *you* have the data to prove it.

Not national data. Not industry-wide data. *Your* data about *your* impact.

So, when you say, "We produce art, which makes the community a better place," you're lying. Either to the community, to yourself, or both.

Not misstating. Not misremembering. Not misinterpreting.

Lying.

It's equivalent to a library announcing this: "We distribute books, which makes the community a better place." Books do not make a community a better place all by themselves. They are pieces of paper with ink, sometimes bound by cardboard, glue, and other things. They do not even increase literacy or knowledge by virtue of their existence. In fact, there is a preponderance of new ways of consuming the written word— things like blogs and online articles—that prove that books do not provide quantifiable (or even qualitative) data on community literacy. They are books. They are meaningless unless they are read, and even then, only meaningful if one can prove worth.

And the art you produce is meaningless unless you can prove otherwise.

Therefore, if you choose the master of art over the master of community...

Blow it up.

The suggestion to blow up your organization is neither hyperbolic nor exaggeration. It is not a "wake-up call." You've had those for years. There is no negativity implied here, just a spotlight on the role vanity may be playing in your leadership. Sometimes, it's just better for an organization to do the right thing and close (or its leader to resign), instead of the wrong thing and continue without change.

If you (yourself) have decided that the reason you are important to the community is because of the completely subjective notion of excellence...

If your reason is the arrogance of believing that your community somehow needs you, without any proof backing that assessment...

If your reason is that your biggest donors and political buddies take your phone calls and ensure their funding (which ensures that they themselves can attend)...

Blow it up.

After all, how do we prove impact without data? Missions are meaningless without data.

Is this your mission statement?

MISSION STATEMENT

We try to be the leaders in our field in presenting all kinds of whatever kinds of art we really like and it is excellent in quality and pleasing to everyone all the time and we are fiscally responsible, so you should send us money.

If that's even remotely similar to your mission...

Blow it up.

Now, in this Pre-Post-Pandemic, Pre-Post-Racist, Pre-Post-Ageist, Pre-Post-Sexist, Pre-Post-Normal (Normal? What's that?) time where all assumptions about what makes a great nonprofit arts organization work in a community have already

been re-evaluated, it behooves your organization to prove its worth.

Every other nonprofit has to prove its worth. Nonprofit arts organizations are no different. If you cannot, will not, or dismiss the idea of proving your worth—your worth, not the industry's worth—then, well...

Blow it up.

The suggestion to "blow it up" can mean many things. Closing down operations might be the best thing you can do. Or, if you see a solution that doesn't include current leadership because of entrenched daily practices, perhaps a complete leadership overhaul can do the trick. Usually, one or two leaders' departures do not do much in the progress department unless everyone is on board with a new version of the company—rarely the case due to misplaced loyalties and other drags on progress.

"Blowing it up" might be the greatest positive impact your organization has ever had on the industry. And your community. The artists to whom you pay a pittance won't like the lack of work and might even move away. That's on you. Not them, not me, and not anyone else.

Certainly the fallout will be quite a show.

Chapter 5

DEI and the Bathtub

Fill a bathtub with water, about 90% of the way to the top.

Now slowly, gently sit in selfsame bathtub.

What happened? Water spilled over the side. It's kind of a chaotic mess outside the tub.

Now, slowly, get up and step out of the tub. Look at how much water remains.

You now know everything you need to know about how DEI affects the community currently served by your nonprofit arts organization.

The tub represents your nonprofit arts organization.

The water inside the tub before you get in represents your current audience and donor base.

You represent the result of a successful DEI implementation at your mostly white arts organization. On the surface, you don't resemble water at all. However, the amount of water in the human body is about 60%. So 60% of you is comprised of the stuff that you sat in. Your presence, however, conclusively caused some of the water to spill out into untidy puddles outside the tub.

Those puddles represent the people who feel as though the organization no longer appeals to them, not with a fully formed introduction of new, diverse populations and programming. They can't rush out fast enough because to them, the environment caused them to leave. In reality, though, their own biases and toxicity compelled them to leave an environment that had introduced something that was comprised of the same elements as them, just in a different color and form.

Notice, while sitting in the tub, that the water now goes all the way to the top. Introducing a new, diverse sector of people to be regularly involved with your organization might have caused some to leave, but the replacement level is higher than the loss level. In a perfect DEI program, that's exactly what will happen with your organization.

When you stood up, the remaining water represented the remaining traditional (white) folks involved with your organization. They didn't go away. They made room for you; they made room for diversity. All of your white audiences are not bad; they share the organization gladly.

When Did You Realize That Your Race Mattered?

If we have learned nothing else from the stunning movements attacking the injustice surrounding the murders of Black people and other people of color, we've learned that talking about a solution is not the same as deriving one.

In the wake of all this, your organization may have issued a manifesto of sorts. Manifestos are a good start. It's a plan. But as Mike Tyson once said, "Everybody has a plan until they get punched in the mouth."

What happens when you feel the urge to produce an event that is irrelevant to that plan, even if it is an interesting project? Do you throw the plan out? Do you quit?

In the United States, Black lives have to matter a hell of a lot more than they ever did. They just do. The US is a country where most white people—even liberal ones—are confused by the question, "When did you realize your race mattered?" Try asking a white person this. Then ask a Black person. I think you'll be stunned by the results.

Black lives absolutely matter. They never did and still don't to a lot of people in power. Black people have every right to protest with allies—or better yet, accomplices—right beside them.

But before we can get into the idea of DEI and its positive (and numerous) ramifications on your particular nonprofit arts organization, one thing has to happen first, because without it, your DEI is DOA.

Before Anything Else: Pay Transparency Is the Primary Tool for Equity

Let's assume that you are either a) an executive for a nonprofit arts organization; b) a board member of a nonprofit arts organization; or c) a foundation leader that funds nonprofit arts organizations. If you are none of these, read on anyway. Surely something in this applies to your situation.

You're probably a white male—because statistics show that people who fill the roles of a), b), and c) are usually white and male—but for this purpose it doesn't really matter.

Let's assume you know what pay inequity is and you believe it is wrong. (If you do and you don't, respectively, then you might not be paying attention to what's happening in the world.)

Let's assume you believe that pay inequity is still happening at your organization, irrespective of any recent DEI statement or manifesto. Someone in power either hasn't figured out, or refuses to acknowledge that you cannot achieve any of your DEI goals without complete pay transparency. Complete. As in: "Everyone knows what everyone makes, and all salaries are listed in job postings." If that's the case, some might call you either a moron or despicably evil. I only believe that you've been concentrating too much on your day-to-day trudge and know, in your heart of hearts, that someday you'll defeat pay inequity. Someday soon. Please.

In 2022, women make 82 cents for every dollar a man makes for the same work. In 2021, women made 82 cents for every dollar a man made for the same work. At this rate, by the year 3753, if we haven't killed ourselves off, women will make 82 cents for every dollar a man makes for the same work.

From the National Women's Law Center in Washington, DC:

> When an employer asks job applicants what their salary expectations are without providing applicants any information about the pay for the position, women lose out... Transparency around salary ranges provides companies with an opportunity to proactively review and evaluate their compensation practices and address any unjustified disparities between employees...Not providing job applicants the salary range for a position early in the hiring process...perpetuates gender and racial wage gaps.

Pay opaqueness only serves employers who are untrustworthy, incompetent, and deceitful. It's a power play against the current employees and potential employees. If your company chooses to exclude this information or stops it from being available from all your employees, your company is clearly hiding something.

Stop playing games with people's salaries.

Is your employer/employee relationship based on entrapment and deception? How do you think your community—that community you've been entrusted to improve—will react to that?

In case you were wondering, pay inequity is far worse among people of color—not just women, either. So much worse. Pay transparency solves that.

Finally, let's assume that the idea of fixing pay inequity comes with some thousand-part plan whose timetable might synchronize with the sun changing from a yellow giant to an enlarged red giant (expected in approximately 5½ billion years). Do you think that might take a skosh too long?

How about a three-part plan that can happen in minutes? Not years, months, or even days...minutes.

- *Step 1.* Sum up the total salary and benefit pool for all your full-time employees, including the executive director, all officers (development, artistic, marketing, production, education, etc.), and the like. Keep the organizational chart as flat as possible as you do this. Sum up both the hours and the total salary and benefit pool for your part-time employees.
- *Step 2.* Divide the full-time "director" salary pool by the number of full-time directors. Pay all your directors, including the executive director, exactly the same amount of money, including offering exactly the same benefits. Same with full-time non-directors. In the same spirit, divide the salary pool for the part-time employees by the number of hours; that should give you the hourly part-time rate. Pay all your part-time employees exactly the same amount of money, including exactly the same benefits.
- *Step 3.* Publish that information on your website, to your employees, to your colleagues and competitors, and to anyone whose ears perk up when you mention that you have solved pay inequity (see chart).

Full Time Directors	6	$425,000		Hr Rate:	$34.72
				Plus Benefits	
Director		$70,833			
Director		$70,833			
Director		$70,833			
Director		$70,833			
Director		$70,833			
Director		$70,833			

Full Time Non-Directors	9	$400,000		Hr Rate:	$21.79
				Plus Benefits	
Associate		$44,444			
Associate		$44,444			
Associate		$44,444			
Associate		$44,444			
Associate		$44,444			
Associate		$44,444			
Associate		$44,444			
Associate		$44,444			
Associate		$44,444			

Part-Time Employees	15	$175,000	8,750 Hours	Hr Rate:	$20.00
PT		$3,000	150		
PT		$4,000	200		
PT		$4,000	200		
PT		$6,000	300		
PT		$6,000	300		
PT		$8,000	400		
PT		$8,000	400		
PT		$10,000	500		
PT		$10,000	500		
PT		$14,000	700		
PT		$14,000	700		
PT		$20,000	1000		
PT		$20,000	1000		
PT		$24,000	1200		
PT		$24,000	1200		

That's it.

The whole process should take about 15 minutes, but sometimes math is hard. Who knows? It might take a whole hour. Go public with it.

Okay, I lied. There's a fourth step.

- *Step 4.* Implementation. While the first three steps comprise a simple, middle-school math story problem, implementation requires a strong spine, psychological acumen, and the stones to stand strong against a sea of "unfair," "too fast," "I quit," and "but what about...?"

Larger arts organizations with bloated executive and artistic salaries (anything over $200K is bloated, even for a $100 million budget, which is also bloated) are increasingly creating a critical wage gap, more than it has ever been.

Don't forget: a lot of your salary information is available to the general public. Part VII, Section A of every IRS form 990 shows officer and key employee wages.

Pay inequity generally increases with the bloat. And just because the board members (who may well be overpaid in their own jobs) believe that this kind of remuneration is necessary, just know that those executive and artistic leaders are looking for new jobs if the company is inequitable or difficult.

"But wait!" you say. "There's a clause in the employment contract that doesn't allow salary to be discussed among employees."

If you believe this, you've been brainwashed to believe that sharing salary information is either unfair, improper, or, as Thurston Howell might say between clenched teeth, "It's just not done, Lovey." Some believe it's illegal, especially if it is written into an employment contract.

It is not.

Under the National Labor Relations Act (NLRA or the Act), employees have the right to communicate with other employees at their workplace about their wages. Wages are a vital term and condition of employment, and discussions of wages are often preliminary to organizing or other actions for mutual aid or protection.

I'm continually shocked that people don't know this.

And, as any labor attorney will tell you, an illegal clause in a contract is not only unenforceable, but also may sever the entire contract. It's like putting, "Employee may murder any or all of his or her workmates, at the discretion of the Company." Illegal, unenforceable, and let's face it, a little sick. So you might as well delete the murder clause, too.

You might lose some employees. Their salaries might have to be adjusted downward, which will not sit well with them. Or, they might have years of experience, in which case they might be headhunted. With The Great Resignation still happening, you're bound to be worried that you might not be able to find good employees. These are reasonable fears, but do not take into account the general job behaviors of today's nonprofit employees.

Nonprofit arts employees (like most employees in general) no longer want to stay at the same job for 20 years. They are more mobile. More urgent matters (home, family, etc.) have made them reevaluate their priorities (or else there never would have been a Great Resignation).

In general, when employees guided by purpose rather than paycheck choose to leave, any number of reasons could be responsible. Including, perhaps most prominently, the loss of purpose. Still, some will leave anyway, but if equity is your goal, you have to take that risk and deal with the consequences.

The thing is, once you've become a company with equity at its center, yours would become the kind of company people quit their jobs in order to join.

Use your powers of persuasion to let them know, one by one, that changes to make the company more equitable are coming. If they want to be seen as a champion of equity, they'll stay. If not, good riddance, and, to repeat, your company suddenly will become *the* place to work.

Of course, achieving pay equity doesn't solve your ageist, racist, or ethnic inequities.

But you can't call your company a champion of diversity and equity if you don't conquer pay transparency first. Plus, if you're the leader who does that about-face, your organization will gain in reputation. They might even name the practice after your organization. As in: "Hey, did your company ACME your salaries yet?"

Cultural Fit Is a Throwback to High-School Cliques

There are other kinds of groups who have felt the oppressive thumb of discrimination as well.

In the HR world, it happens all the time. It's totally illegal, but nothing ever happens to the guilty party. It's like the practice of "redlining." If no one puts it on paper, it's very hard to prove and, in the case of employment, hard for the complainant to get hired afterward, even if proven correct. Discrimination has to stop.

In the hiring environment, a hiring manager can simply say, without penalty, that the candidate is not a good "cultural fit." *Every time that excuse is used*, it is a symbol of a company that engages discriminatory practices. "Cultural fit" means one and only one thing to a candidate: a bigoted, inequitable company that only wants to hire either clones of themselves or an old stereotype of what that person ought to be. The company may claim that the practice is legal and that "cultural fit" is fair game.

It is not. "Cultural fit" is a phrase of exclusion. Last I checked, "exclusion" is the opposite of "inclusion."

The problem with cultural fit is that, for lack of a better term, it's stupid, lazy, and prejudiced. Cultural fit works for Scientology, Skull and Bones, and the KKK. It does not work for a charity organization and it reveals a malicious streak in your company's core ideology.

> "What most people mean by 'cultural fit' is hiring people they'd like to have a beer with," says Patty McCord, a human-resources consultant and former chief talent officer at Netflix. "You end up with this big, homogenous culture where everybody looks alike, everybody thinks alike, and everybody likes drinking beer at 3 o'clock in the afternoon with the bros," she says.
> —Sue Shellenbarger, *The Wall Street Journal*

Which leads to the obvious question: how will you verify the results of your new diversity initiatives? What are the benchmarks? Do they include older workers? Workers who are neither Black nor white? Immigrant workers? Disabled workers?

And to whom will your services be directed? Surely, you cannot only present works for the pleasure of moneyed, mostly white people (a.k.a. "big donors"), can you? Still? And yet, you cannot simply present one Black-created/Latino-created/ homeless-created event per year and call it a day, can you?

Nonprofit arts organizations—leaders and board members alike: implore yourselves to do better. Character is measured by acting heroically when no one is watching, not when forced to act as a punishment.

Do better. Prove how. Or risk being exposed as hypocrites and killing the company.

Receipts are being printed every day.

On His Way Out of the Office, He Said with a Smile, "You Don't Buy a Dog and Then Bark, Too"

Hold that sentence in your mind for a couple of minutes as you read this story.

You're a white person and you're not a bigot. You're progressive. You run a nonprofit arts organization. And you were outraged.

You saw replays, over and over, of the murder of George Floyd. You read the accounts of the murder of Breonna Taylor. You saw the demented murderous footage of Ahmaud Arbery shot by rednecks in a pickup. You saw Jacob Blake get shot seven times in the back.

You wanted to show your support.

First, you bought a BLACK LIVES MATTER T-shirt. The proceeds went to an anti-racism organization, the name of which you might remember. Or you might not.

Then you wore your T-shirt to a Black Lives Matter protest.

You called all your Black friends to see if they were all right. You asked them for help in understanding the issues. When each one of them explained to you that their individual opinion did not represent every Black person in America, you disregarded it. Your board president suggested strongly that you write a manifesto for the company, a word usually reserved for political or social causes. You thought it might be a good idea. You saw one from a company that was two thousand miles away. That company will never notice that you just plagiarized their words without credit. You wrote the same thing, word for word, and put it out there for everyone to see.

Right smack dab in the middle of your website's home page. As a pop-up.

Your board had a special meeting. You talked to some of your foundation contacts. You wanted to find a way to increase the board's diversity. Perhaps there was funding for that?

You forgot for a moment how outraged you were. But then you remembered again. Your board added two Black members and two Latino members. Weirdly (at least to you in the thick of the activity), four white members quit.

You quickly hired a director of diversity, education, and inclusion. You told her that you wanted her to build relationships in the community without losing the relationships the company already had. This was code for:

We can't lose the rich white folks. We just want the other folks added on top. How can we "hold on to our base" (your actual words) and add all the people of color, too?

She told you that you were micromanaging in the worst possible way. You didn't understand why she quit. You hired another DEI director, then another one. The same thing kept happening. Why couldn't they understand the reality of the situation, that the company was dependent on the kindness of "good people on both sides"?

You fired your fifth DEI director. *On his way out of the office, he said with a smile, "You don't buy a dog and then bark, too."*

Your company still did not become diversified. You told the board that the process would require baby steps. You chose to do August Wilson's twentieth-century cycle of the Black experience, one play at a time, for the next ten years. Surely that would do it, right?

It's now 2040. How did things go?

Here's the thing: in order to remake your business into a consummate anti-racial nonprofit organization, small increments will not do. Change will have to come in large doses with a great deal of speed. You cannot afford to diddle around with baby steps that are, after all is said and done, ineffectual. Baby steps, in this case, are for babies.

For diversity, equity, and inclusion to be meaningful, you're going to have to lead a changed mindset for the company. For

one thing, is it a "club"? If so, remember what Groucho Marx said about clubs: "I refuse to join a club that would have me as a member."

That said, in order to be truly anti-racist; in order for your company to tell the stories of people of color; in order for your nonprofit arts organization to become a beacon for all people rather than the plantation house of one of the "good" families, you have to change your point of view. And, if you're a white Anglo-Saxon Protestant, you're going to need new people on board who can speak authentically about the issues at hand. Otherwise, you'll look as though you're pandering, instead of choosing to do the right thing.

You *are* choosing to do the right thing, right? You're not pandering, right?

By changing your company's purpose and direction and guiding it toward equitable results, you are not merely risking losing a portion of your audience, but you have to be counting on it.

And celebrating it.

Because, finally, your company will be able to have its best impact. As Jim Collins might have said, you will have put the right people in the right seats on the bus. This is a good thing.

Michael J. Bobbitt, the executive director for the Mass Cultural Council, put it best in an article he wrote for *American Theatre* in December 2020:

Predominantly white institutions exist for one main reason: racism. However you view it—whether it's explicit, implicit, or complicit—the reason they are predominantly white is the same: racism. If this is an uncomfortable realization, embrace the discomfort and use it to make change. Change requires confession, redesign, investigation, reflection, and the pursuit of growth. The Black, Indigenous and people of

color (BIPOC) folks I know love theater—just maybe not at predominantly white theaters. And why should they? Those theaters are not meant for them, except on occasion.

Fire your racist staff members and your racist board members, and hire new people from completely differing races, ethnicities, and religious beliefs. That's easy. Well, not easy perhaps, but at least it's something you can control.

Now fire your racist audience members. And donors. And hire new audience members and donors from completely differing races, ethnicities, and religious beliefs.

Yes, that is within your power. It speaks to your purpose for producing.

There are few, if any, large arts organizations whose audiences match the demographics of the cities in which they do business. That has to be fixed, and there's only one way to do it.

In the US, for the arts to be whole, many of the 1%—even some of the "good ones"—are going to have to be fired. Fired from boards, foundations, and staffs, certainly, but also fired from audiences and donor bases. If we are to move quickly toward doing the right thing—both artists and audiences—we have to tell stories using the prism of each and every culture, not through a prism of white interpretation of those cultures. And Black, Latinx, Asian, and other artists of color have to be given the biggest opportunities to tell these stories, not as a one-off per season, but consistently and determinedly in order to gain trust—because these same artists and audiences have been burned many times before. You might lose money at first. But doing the right thing *because it's the right thing to do* often causes an organization to lose money at first.

If you don't choose to fire all the racists, why the hell did you buy that BLACK LIVES MATTER T-shirt?

Equity (the Concept, Not the Union)

I believe that the most important letter in DEI is the E. Diversity and Inclusion can only help your community when they happen Equitably. Otherwise, D is for Token and I is for Obligatory.

The worst-run arts organizations are those that trumpet the idea of being "something for everyone." The best use boundaries to help them focus on good acts for their communities. By abdicating concentration on solving a societal issue in order to offer happy-dappy programs suitable for every living person, they fall into the trap of losing power. No one will—or should— trust them to do what it is that they do best if they don't profess to know what that is.

The Annie E. Casey Foundation discussed the difference between "equity" and "equality":

> Equity involves trying to understand and give people what they need to enjoy full, healthy lives. Equality, in contrast, aims to ensure that everyone gets the same things in order to enjoy full, healthy lives. Like equity, equality aims to promote fairness and justice, but it can only work if everyone starts from the same place and needs the same things.

Equity is an active concept; equality is a passive concept. "Give people what they need" vs. "Give people the same things."

Equality is a ticket window. Open to the public. Anyone can buy a ticket. Step right up. The responsibility is on the patron to buy the ticket, but any patron will do.

Equity requires no ticket window. Instead, it has an active program to ensure that under-represented, ostracized, or historically omitted people attend the event.

Equity is what the Supreme Court dealt with in *Brown v. Board of Education* (1954) when it eliminated the national indignity of "separate but equal."

Before *Brown*, Black children and white children went to separate somethings called "schools." Racists in the region held that Black children had the equal opportunity to learn in school. However, they never funded the Black schools at the same level as the white schools, leading to a problem not of "equality," but of "equity."

In overturning its own ruling of *Plessy v. Ferguson* (1896) that allowed such heinous activity, the Supreme Court determined that equity was a more valid legal concept in the US Constitution. Each child had to be ensured the same opportunity to succeed. The first way to accomplish that, according to the Court and the Brown family, was to desegregate the schools.

That battle continues to be fought, of course. With history books and movie screens filled with epic tales of white supremacy, it is hard to imagine that these horror stories are received equally among children of different ethnicities, religions, and backgrounds. The playing field of life starts unequal. The struggling class—Blacks, Jews, LGBT, Muslims, disabled, etc.—have supremacist societies targeting them in some way from the moment of birth.

That's what needs to change.

This is where equity comes in. And that's where your arts organization comes in. It is not as though equity in your organization will definitely lead to equity in your society, but the reverse is absolutely true: inequity in your organization will continue the inequity in your society.

Equality tells us about battles; equity informs us of all the outcomes on all the sides and what has to happen next to make the world a better place for all its inhabitants, not just the victors. That's your job.

Equity Is to Equality as Inclusion Is to Outreach

Here's a tip: never use the word "outreach." It's insulting. And when you mean "equity," never use the word "equality." They are two completely different things.

There is a direct connection between equality and the worst possible word some nonprofits still use to describe their toe-stubbing, awkward, yet mellifluous DEI efforts: "outreach."

In the antebellum South, some plantation owners were more beneficent than others. Of course, they still owned people, which was an abomination (except in the Bible). But they believed that the slaves were free labor, not living, breathing human beings. As such, they were to be cared for only in the sense that they were important to saving the farms, the plantation, and the way of life of the "real" people, those who were white.

They provided rudimentary education to these slaves in the form of books. They did acts of "outreach," sending redacted bibles to the slaves in their cabins and giving them Sundays off (after a 144-hour workweek).

If they needed assistance reading these doctored bibles (with zero Old Testament passages about slavery and the exodus therefrom), they provided it gladly. After all, what better literature could be provided that would send the message that life is meaningless when compared to a glorious afterlife?

Sending books to the cabins is outreach. Arts organizations with their one Black play per year leads to a special kind of outreach: tokenism.

Donors who give to nonprofits because they want to be perceived as better people than they actually are (e.g., the Sackler family) use money as their outreach token. It means far less to them than it does to a potential nonprofit recipient. When the nonprofit uses the money to send bibles out into the field, the donor gets the credit. A satisfying transaction for everyone except those out in the field.

"Outreach" insults the very core of equity. It also sends the statement: "We only want to talk to you because you're Black." Instead of "outreach," which sets up separate but equal camps (at best), make your efforts "inclusive." Enmesh all participants into partners to create a shared solution for your community.

It's not merely the word "outreach" that offends; it's the activity it represents.

If your arts company is embarking on a newly minted DEI program, you are required to change the way you do business from the top to the bottom, knowing that it will alienate some of the old-time (read: white) participants forever.

It's just like the bathtub. The racists will be upset. Your biggest donors will be upset. Corporate heads will be upset. Board members will be upset. All of those people will end up on the bathroom floor in chaotic puddles, never to darken your door again.

If you're a nonprofit service organization (which is what a nonprofit arts organization is, according to the IRS), then for Pete's sake, *serve*. Your goal is to achieve impact, not profit. And you can't serve with supercilious, perfunctory statements of equality and outreach.

You can only do it with actions of equity and inclusion. Actions, not words.

Each Community Has Different DEI Issues, Including Your Own

There are no neat, clean rules on how to infuse DEI into your organization. There aren't. There are some wonderful consultants out there who can help your organization along in changing your collective perspective to view the work, the process, and the world around you from a white-dominated society to a non-dominated society. It's very hard work, and not always successful. And any consultant, especially a nonprofit arts consultant, who claims they can do that for you, but has no *bona fides* in the multitude of cultures that exist, not only in your community but in life, is bogus.

I am not a DEI consultant. I am aware of many programs and tools and I want DEI programs to succeed. But you would never hire me for that issue, even if you think I know my stuff,

because (to my knowledge) I have never spent a day as a Black person. Or as a Latino. Or as a member of the LGBT community. And all that matters.

I am Jewish, which offers its own discriminatory issues. In college, I was told by an MFA director candidate, "You people are only good for musicals and Noël Coward plays." Backstage of a play in the Midwest, I was asked, "Why did you kill our Lord Savior, Jesus Christ?" to which I responded, "It wasn't me. It was my dad." So maybe I can help with that problem.

It doesn't mean that any ideas I might have aren't sound. It just means that there are people out there who have *lived* the problem with a great deal more insight than I. Look for them.

The point is this: do your work. Your "due diligence." Consider what goals you have for your artistic planning. *Again, not your artistic goals; your goals to help your community.* Talk to others. Know that some of your "regular" (read: white and somewhat racist) people might leave. Risk losing them, because the goal of a nonprofit is to serve, not to survive.

In the mid-1990s, I worked for Pittsburgh Public Theater, which still performed in the old Carnegie Hall on the city's North Side. At the time, *US News & World Report* rated Pittsburgh as the best place to live in the United States. Crime was low, traffic was light, and housing costs were tiny compared to many other cities. There were parks aplenty, cultural advantages, and lots of places for recreation and sightseeing. And, of course, the Steelers (pronounced by native Pittsburghers as "Stillers").

But like every older, white-founded city in the United States, Pittsburgh had a race problem. Likely, it still does.

The city's neighborhoods were carved out and populated by specific racial and ethnic groups. Jews lived in Squirrel Hill. Black people lived in the Hill District. There were German (Catholic) neighborhoods, Italian (Catholic) neighborhoods, Polish (Catholic) neighborhoods, and more.

Then, as now, the population was almost entirely white. Somewhere between 80 and 90%.

And the suburbs were even whiter, as they often are.

But this story is about a different kind of diversity: age diversity. During the 1980s and 1990s, the youth population left town as quickly as they could. Some of the telling statistics were: Allegheny County, Pennsylvania (at the time) had the oldest mean population in the United States, edging out Dade County, Florida. People lived in their homes in Allegheny County longer than any other county in the country, an *average* of 12 years, which included transient student housing at the University of Pittsburgh, Carnegie Mellon University, and Duquesne University, among others.

And at the theater, a stunning set of data came from an audience research project my team put together while I was there.

In 1994, the median age of a ticket-buyer was 63. She (60%) was married and lived in a single-income home where she was the one not in the workforce. There were no kids in the house — in some cases, there were no kids at all. The education level of both wife and husband was exceptionally high, as more than 80% had bachelor's degrees. The household income level was quite high, especially for Pittsburgh, well into six figures.

During the theater's early years in the mid-1970s, a similar audience research project took place. The median age of a ticket-buyer was 45. She (60%) was married and lived in a single-income home where she was the one not in the workforce. There were usually kids in the house, but old enough to leave alone in the evenings (or easy babysitting was available from the older generation). In some cases, there were no kids at all. The education level of both wife and husband was exceptionally high, as more than 50% of the men had bachelor's degrees. The household income level was quite high, especially for Pittsburgh, around $55,000 a year.

It was the same woman.

I raised this at a LORT (League of Resident Theatres) conference held in Denver that year during a panel discussion about the graying of the audience. (It was already white, but now it was gray, too.) Just in case you believe that a graying audience problem is new, the theater community recognized this as a problem in the 1990s.

We didn't *do* anything about it, but we saw the avalanche of gray falling toward us.

Few marketing professionals who sat on that panel with me thought the aging was a problem. The general consensus among them was, "Well, that's our audience, so that's who comes. And when the 40-year-olds become 60, they'll come, too."

I disagreed, of course, and noted that people who don't come to the theater don't just start coming to the theater because they're 60. Call me crazy, but to me it sounded like they were connecting two incongruent thoughts. Something like "Grass is green, so the Pirates are going to win the pennant."

The light moment of the discussion came when one of the panelists, the marketing director for the Denver Center Theatre Company, said that in Denver, his sexagenarians were extremely active. "They ski in the winter and ride mountain bikes in the summer. They eat healthy food and drink a lot of water. They're going to live to be 100, so we have a long-term future together."

It was a ridiculous point, of course. There was still no plan to find new patrons, so the death of the industry would just come a few years later, according to this marketing director's pretzel logic.

"My sexagenarians," I replied to this Coloradan, "live in Pittsburgh, where they're sedentary; eat pounds of kielbasa and pierogies; drink a lot of Iron City Beer; and put french fries *inside* their pastrami sandwiches along with Russian dressing, sauerkraut, and cheese."

"Hell, I'm surprised they're alive *now*."

Concerned, I took this information to the rest of the executive staff, the board of directors, and several community organizers within the city. I asked them to clear all their conventions of how attractive theater might be to younger people (defined then as "Under 45"). During the process, which included follow-up surveys, focus groups, and other various research activities, we changed our thinking about who attends the arts. The chief predictor, we discovered, was education level.

Specifically, the *aspirational education level* was the most important criterion for arts participation. That is, regardless of income level, those who seek a high education level were more likely to support the arts by attendance and contribution than those who did not. The generalized example of that theory was this: a starving MA student on a scholarship is far more likely to attend a play than a millionaire cattle rancher with little formal education.

With that knowledge, we quickly concluded that the long-term success of the organization was rooted in the younger half of the audience base we were seeking. We studied the behavior and the upbringing of educationally aspirational people under the age of 25.

Their world was quite different from the world of two generations previous, when subscribing and getting the best seats raised status within the community. Status was not the issue with the Under 25s. Even price was not necessarily the issue. The opportunity to reach the Under 25s was getting them to belong to an organization that drew other Under 25s, enough to create a critical mass. In this way, they felt welcome as one would at a party in which the other people there are already friends.

To attract them, I asked my marketing team to help me create and implement the "Under 25? Only $10!" program. Simply put, anyone under 25 could purchase a ticket to any performance of any production of any play at Pittsburgh Public Theater for only $10. There were no restrictions at all.

Under 25s could buy in advance, use a credit card, and even get fifth-row center seats if that was what was available. By removing the second-class status and allowing this important group first-class access at an affordable price, we were able to change the face of the organization.

The price was key: at $10, they could afford to take a chance. In the old student-rush program, once they were no longer in school (and had student debt up to their eyeballs), paying $50 for a theater ticket seemed a futile course of action.

In the first year alone, we grew from an organization that had sold 800 student-rush tickets to 4,900 "Under 25s." That number grew to 7,000 during the second year.

As its director of marketing and communications, I instituted this program at Seattle Rep in 1997 and the same metric grew in an even more astonishing way.

During the year before my arrival, 1,200 tickets were sold through a traditional student-rush program. During my first year, we drew 7,600 "Under 25s." That number exceeded 10,000 during the successive year. I understand that, after I left the Rep, the number peaked at about 20,000 per year out of 60,000 single tickets sold.

There were follow-up programs that had been planned, but scuttled after I left, which was too bad. The idea was to bring these initial groups of people along, continue to have relationships with them (and not ask them for donations). We would have continued to send them materials, even after they had aged out of the program, with special deep discounts that were only for them.

Finally, while it was not a primary goal of the diversification of the audience, we had noted that those under 25 were more likely to have connections, friends, and co-workers who were comprised of all sorts of ethnic, religious, and cultural diversity. There was an indirect hope that they might come to the theater, too. However, with mostly white programming, the

token August Wilson play (in both theaters), and every now and then a contemporary play by a leading writer about the Black experience, that didn't really happen much.

The thinking was this: the second outcome that a high educational aspiration predicts is high salary. That being the case, our goal was to stay in touch for enough years (maybe ten) to get them through their salad days. This highly educated group would have the best chance of becoming high wage earners at 35 and thus, be able to be asked to help subsidize the next version of them: the next "Under 25s." In that way, the program could be self-perpetuating.

But, to my knowledge, that never happened at Pittsburgh Public Theater or at Seattle Rep. Instead, the latter's development department began asking them for money right away, created a junior donor program filled with the sons and daughters of industry, and they raised the price. Some arts organizations were bullied by their insatiable board members and executive directors to eliminate the program because the revenue was so scant. I think you won't be surprised to see that there are thousands of nonprofit arts organizations currently fretting about the fact that their audiences are comprised of 80-year-olds.

Diversity: Not Just a Black and White Issue; Ageism Is Worse

The purpose of the discussion of the "Under 25" program is to recognize that there are numerous diversities that need to be addressed in the nonprofit arts organization sector, on all sides of all footlights. Alphabetically...

- Age
- Distance
- Economic status
- Educational achievement

- Ethnicity
- Gender
- Orientation
- Race
- Religion
- Socioeconomic status

There are more, and I believe there are myriad ways of enacting DEI tasks while acknowledging the breadth of the issue. To that end, I'll take a stab at addressing ageism in the workplace, the quietest, most insidious, and most acceptable illegal activity happening in your nonprofit right now.

Oh, you think it isn't? Think again as you read the following.

Ageism is alive and deadly. It thrives because there is no pushback. Proof is difficult and there is no reckoning, even for companies with dozens of complaints. And even though there is a federal agency in the United States, the Equal Employment Opportunity Commission (EEOC), that works on behalf of those against whom companies have discriminated, in the real world of business, ageism continues to go unreported.

> Under the laws enforced by EEOC, it is illegal to discriminate against someone (applicant or employee) because of that person's race, color, religion, sex (including gender identity, sexual orientation, and pregnancy), national origin, age (40 or older), disability, or genetic information. It is also illegal to retaliate against a person because he or she complained about discrimination, filed a charge of discrimination, or participated in an employment discrimination investigation or lawsuit.
>
> (EEOC, 2018)

Seems pretty cut-and-dried, does it not? The specificity of the age provision became law in 1967. Over 50 years ago. And yet...

Despite decades of research finding that age does not predict ability or performance, employers often fall back on precisely the ageist stereotypes the ADEA was enacted to prohibit. After 50 years of a federal law whose purpose is to promote the employment of older workers based on ability, age discrimination remains too common and too accepted. Indeed, 6 out of 10 older workers have seen or experienced age discrimination in the workplace and 90 percent of those say it is common.

(EEOC, 2018)

The prejudice against those over a certain age withers in comparison to that experienced by Black folks, of course. Generally speaking, some redneck in a pickup, some militaristic, minutely schlonged cop, or some ridiculous puppet insurrectionist (complete with swastika tattoo and confederate flag bumper sticker) will not shoot a white person for being over 55. Unless that person is Jewish. Or, somehow, Black.

But—and this is a big request—it is incumbent upon all of us to band together to fight this battle.

Because ageism is a personal abomination and reminds targets that their age, values, accomplishments, and the diminishing years of their life somehow disqualify them from achieving goals, it is often easier to decry the practice as anti-something-else. "I *didn't not* get hired because I'm too old," someone over 55 might say. "I'm just too [Black, Jewish, Muslim, female, etc.]."

The intriguing thing about ageism is that it will likely be practiced against the very human beings that are guilty of perpetrating it now. If they live long enough. And they'll be shocked when it happens.

In the last few years, since the inception of the COVID-19 pandemic, we have taken part in more Zoom meetings than we ever wanted. The Jetsons predicted it back in the 1960s.

But the technology met opportunity when the global pandemic hit. Suddenly, we all became talking heads repeating the same things to each other. You're on mute. I can only see your forehead. Your dog is barking. My dog is barking. Outside, the cast of *101 Dalmatians* is barking. Why do you look green? Who is talking to me? How can I see your reactions if I'm only looking at the camera dot?

Et cetera.

It has exacerbated the ageism problem. What potentially attracted an employer to a worker with experience, savvy, problem-solving abilities, and mentoring skills has inadvertently become a huge obstacle to employment because these are unrelatable skills on a glitchy internet connection screen. A candidate's face may trigger feelings of "Oh, that person is too old" from well-meaning but ageist interviewers. Search consultants do it all the time, driven by clients who let them know in so many (spoken, never written) words not to hire anyone over 40.

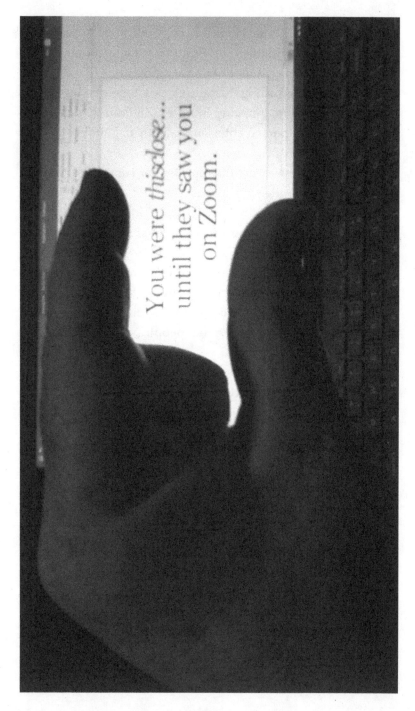

You were *thisclose*... until they saw you on Zoom.

Nothing makes a Zoom interview go well, to be sure, unless you're in a studio with the right lighting, camera/sound person, and hermetically sealed quiet as a background.

As a result, according to figures put together by AARP, fewer older workers are being hired by Zoom interviews than were hired by in-person interviews, both in number and by percentage.

Zoom isn't going away. It's too easy for companies to use it and then to blame their hiring practices not on ageism, but on perceived technophobia. So, what can we do?

Now that people are (mostly) vaccinated, we have no excuse to use Zoom to interview potential workers. None.

And we have to look at our companies' practice—not the practice of current workers, but of those hired in the last two to three years—and compile ageist practices across our companies. Otherwise, good people will be left on the sidelines.

The Bill of (Candidates') Rights

This falls squarely on the shoulders of HR professionals who too often appear to be the loudest proponents of ageist discrimination in the corporate community. Check out your LinkedIn feed for some of the whiniest, most defensive posts on the subject. For them, here is a Bill of Candidates' Rights:

The Right to Revealed Salary Ranges

Not showing the salary range in a job post invites age discrimination, gender pay inequity, and power plays among employers to the detriment of their relationships with employees. Companies are inviting lawsuits after hiring because employees WILL discuss salaries, regardless of "what the hiring manager wants."

The Right to Be Qualified

There is no such thing as "over-qualified." Do not assume candidates are stupid. Take at face value that a candidate is applying for the job the candidate wants. If a seasoned worker aged 55–64 is applying for an entry-level position and is qualified, bring them in. They know what's in store and had a valid reason to apply.

The Right to Be My Age

Discuss the best way to train managers under 40 how to work with those older than they are. Take the same training with them. After all, it is intimidating for the average 35-year-old to tell a 55-year-old what to do. As a result, the 35-year-old will almost always opt to hire someone younger (and, presumably, less threatening). Shortsighted thinking dooms a company to incompetence.

The Right to Interview in Person

Zoom interviews do a disservice to everyone involved. Now that it is possible to interview in person, do it.

The Right to a Reasonably Quick Answer

Do not ghost a candidate. It's not only rude (which makes you a terrible person); it also reveals your company to be an abysmal place to work. Send a note. Give them a call.

It's time to come down—HARD—on any company that doesn't practice this through their most-feared vulnerability: reputation. A series of justifiable and intelligently written social media posts or reviews on Glassdoor, LinkedIn, Indeed, and other sites may work their way up the chain when the rating of the company sinks to a dangerously low level.

Even then, it might not get better. But it definitely won't get better if nothing is done.

Ageism, Redux: When You Don't Consider Those Over 40, You're Breaking the Law (and You're Killing Your Organization)

Too many HR professionals, both within organizations and those who are contracted, respond to their notion of "the customer is always right" (another version of that saying is, "I want to get paid") by searching for, almost literally, the physical and educational characteristics of the former employee. Or, despicably, they'll look for a younger version of themselves.

It's their nature.

Rather than looking for the "best person for the job," which is what they're saying they're doing, they look for the "last person in the job."

It's their nature.

The following appeared in a real LinkedIn post by a search consultant in 2019:

Not too many years ago, a Chief Operating Officer from a packaging design firm in New York called me. After saying she was struggling hiring—she said "I want you to work with us, but WHATEVER YOU DO, DON'T SEND ME RESUMES OF PEOPLE OVER 40." I replied, "ARE YOU HIGH?" She said no. She was serious. I asked her if she was aware that discrimination was illegal in the United States but she said, and I quote "IMPOSSIBLE TO PROVE!" I hung up on her. She's still there, and still discriminating. If you're a recruiter and take on these jobs, there's something wrong with you.

Remember, this was *before* the pandemic. By 2022, millions of people had quit their jobs because they no longer wanted to be exploited. News outlets reported that there are open jobs

aplenty. Meanwhile, the news is also out there that people over 50 are not even being interviewed for those open positions. It's completely illegal, and it's done all the time.

Is it the fault of the HR pro that the client only wants younger talent? Sometimes it is, and here's when:

If the HR pro has made it clear that they will not engage in discriminatory practices—even when no one is looking—then it is up to the client whether to follow the law. If the client wants to flout the law, it leaves the HR pro with two choices: 1) walk away and don't get paid; or 2) bend over, take it, and get paid.

If the HR pro rails against this as a false dichotomy by saying that they have been placed in an untenable position, remember that the HR pro did this to themselves. No one has forced them to do this particular task. The law, no matter how inconvenient, is the law—and it's a good law.

Ageism goes both ways, in case you're *under* a certain age. Entry-level jobs should not require *any* experience. But look at the job postings. Jobs listed as "entry-level" are requiring three, four, five, ten years of experience now.

Entry-level positions, by definition, should not require ten years of experience. But by calling it an entry-level job, the company asserts its right to pay entry-level wages. It's a malevolent Catch-22. How can an entry-level candidate already have ten years of experience?

The upshot of all this ageism? Companies that don't work well. Non-innovation. Temporary employment. Continual turnover. Unnecessary HR expense. Untrained managers at all levels. Companies are afraid of litigation, so their focus is not on eliminating ageism, but instead, avoiding claims of ageism.

Here's a simple idea.

Why not avoid claims of ageism by choosing not to be ageist?

It's not only the legal, honorable, and righteous thing to do; it's also better business to hire and hold on to employees who have seen and solved problems for years. You might not want

to have a beer with someone 25 years older than you, but you might take a shining to that financial surplus at the end of the year.

"Companies don't really measure the value of intellectual property that sits in these individuals," says Andres Tapia, global diversity, equity, and inclusion strategist at the management consultant Korn Ferry. "They generate great ideas and experiences, and then all of that walks out the door."

Whatever You Do, Don't Be the Kennedy Center, at Least for This Section

In March 2022, I emailed the Kennedy Center HR department to ask why it does not show the salary on almost all of its job openings.

This was the question posed, verbatim:

One of the chief complaints of qualified people looking for work is that salaries are not listed in the posts, which leads to inevitable pay equity issues at the workplace. A colleague of mine noticed that only a tiny few of the 48 job openings at the Kennedy Center show the salary. Of course, my first question is "why?"

With all the grand language the company has put together in its social credo (and other places, including a lovely DEI section on the website in human resources), it seems counter to the cause not to list salaries. In fact, it's one of the biggest reasons for qualified people not to apply at all—they won't trust you, and with The Great Resignation, *they have a boatload of companies who will, and do list their salaries right on the announcement.*

There was no answer. Perhaps the email was lost or misdirected. So I called and spoke to someone in HR/Talent.

No answer from that person, but a promise to get the question to someone who *could* answer that question.

Later that day, I did receive a call back, requesting an email be sent to hr@kennedy-center.org. Here was that email.

Given gender pay equity issues in America and the DEI manifestos of the Kennedy Center, I was surprised to discover that you don't list salaries in nearly all of your job listings. In this "Great Resignation" economy, most qualified women and people of color will not consider positions that do not show the salary in the job posting. Why would you want to exclude them?

Twenty-four hours passed.

I happened across the Kennedy Center website.

As the National Cultural Center, the Kennedy Center has a unique and urgent responsibility to turn symbolic gestures into tangible systems. On June 2, 2020 we made a statement to hold this institution accountable and ensure that the Center is always home for critical conversation about race and discrimination.

Except, clearly, discrimination based on salary.

In the fiscal year that ended on September 30, 2019, the president of this nonprofit organization made $14 every 81 seconds. The lowest salary came to $14 per hour (3,600 seconds).

What if there were a rule/law among nonprofits that a CEO/president/executive director could earn no more than seven times the lowest full-time employee's pay? Given the power of that job, would there be a significant talent drop? Or would the lowest-paid employees get a boost in pay?

Maybe, and maybe not, respectively.

Two days in. No response.

From the BBC:

Equality also extends to helping improve the gender pay gap. Pay transparency actually closes that gender pay gap, and that's likely because we know that women are less likely to negotiate and more likely to be penalized for asking for higher pay.

Three days in. No response.

Without the transparency of showing the salary in a job post—or a total transparency—nonprofits who claim to be working on diversity, equity, and inclusion can escape without offering proof of diversity, equity, or inclusion.

From a 2020 article in *Charity Village*:

"Without transparency," says Jane Garthson, president of the Garthson Leadership Centre, "how can you tell whether an organization pays both women and men fairly?" Audra Williams of Townhall Communications agrees: "Studies show that women don't negotiate salaries or talk about money. This pay equity issue is aggravated by not knowing what a job will pay."

It would not be a stretch to apply that same reticence to any people who do not historically enjoy the same privilege as white men.

Somehow, taking advantage of fear-based, ingrained tendencies to "play nice" in a job interview by not sharing the salary for your nonprofit—which, we all know, has a specific budget number attached to it (duh)—is considered established practice. The Kennedy Center must feel that equity is not really necessary if you're a woman, Black, Latinx, or otherwise non-white male.

Four days.

Five days.

Six days.

A week passed. And another week. And another. Then another month. And another. And another...

It seems obvious that the Kennedy Center doesn't really want to answer the question. Perhaps they believe that showing the salary might encourage less qualified people to ask for more money. Of course, they probably shouldn't be interviewing less qualified people. Or, if the job is what the job is, perhaps they should pay the salary that job deserves rather than pre-judging qualifications.

In the meantime, the 990 tax form is publicly available. It includes salaries and benefits for anyone considered a "key employee." You can find it through Candid.com or by just asking for it from the organization. If they are reticent to share it or only want to show you the first two pages (although that would be illegal), that says more about them than it does about you.

You can do better than having your employer hide the truth from you. President John F. Kennedy, the namesake of the company, a man who believed in equal rights, is turning over in his grave.

I don't expect a response will ever come. Too bad.

Maybe that's why this story made it into this book.

Chapter 6

Because, You Know, the Pandemic

This is a very short chapter. You might well know most of the information that follows. You might not. The details are important, if only to recount the one major event that changed the world in one fell swoop. What I've discovered is that Americans have a memory problem. The next shiny thing distracts many from what really happened, leading to things like "alternative facts," where a group cynically manipulates their followers to serve an ulterior motive.

These are not all the facts, of course. When you talk about COVID with your colleagues, especially those whose memory of it might be from childhood (or from an untrustworthy news source), please insert your own memories.

We should never forget what happened. It's going to happen again, and we don't have to waste time panicking about what to do next.

You can check with the Centers for Disease Control for data on COVID. Millions have died, millions more have been hospitalized, and there is still unknown data about the effects of Long-Term COVID, which includes permanent damage to a number of organs.

Sociological issues came forth with the prevalence of COVID, including Anti-Asian American Hate (because the virus came from an open market in the Wuhan province in China); anti-science agendas that kept over one-third of the United States from vaccinating themselves because of, for lack of a better reason, "freedom"; and an America that had been ideologically divided since its birth was pulled apart by the naissance of a movement. That movement, originally called "Tea Party Patriots," a right-wing, anti-government neo-militia that called for the abolition

of civility in government, morphed into conspiracy-theory advocates following racist, sexist, homophobic Klansmen. The divide became wider, but it was a divide that already existed in a country that bore the original sin of legal slavery.

But this isn't *only* about COVID. This is about the nonprofit arts industry and what happens next.

One of the first attempts to do a live theatrical event after the onset of the pandemic was a production of *Godspell* in which all the cast members were placed in large, individual plexiglass boxes stacked atop each other. It looked like a cross (no pun intended) between a musical comedy and *Hollywood Squares*.

One movie seemed to capture the angst of the moment, a movie that started shooting at the beginning of the pandemic. *Don't Look Up*, written by Adam McKay and David Sirota, directed by McKay, and starring Academy Award winners Leonardo DiCaprio, Jennifer Lawrence, Meryl Streep, and Cate Blanchett, is a darkly funny ensemble piece. It's a satire about two scientists who discover a comet heading toward Earth that will destroy the planet. The comet's impact is a metaphor for the impact of climate change, but could easily also be an unintended allegory for the politicization of COVID.

Zoom boomed. Streaming services gushed. The arts, like everything else, became virtual.

Many arts organizations closed. Many more became so financially crippled that they're bound to close, even now. Still more moved all their performances online. They deemed it a radical idea. I thought it looked a lot like, I don't know, *television*.

And what we've been seeing in the nonprofit arts industry, as mentioned before, is a strict decline in support. But all in all, that was happening anyway.

The nonprofit performing arts movement in the US tried desperately to stay relevant in these times. For the most part, it failed. This was due (not merely to the closure of performing arts

venues across the country) to years of resistance to performing its charitable duties as a community nonprofit, concentrating instead on producing art for art's sake.

I'll never forget the headline from a Shugoll Research report dated May 11, 2020:

> Survey Finds Many Theatergoers Nationally Will Not Immediately Return to Theaters When They Eventually Reopen in the Wake of the Coronavirus Pandemic

Duh.

It may seem obvious now, but only at that moment were arts leaders realizing that their arts organization might not be in Kansas anymore, so to speak.

It is an easy conclusion, then, to determine that the onset of COVID did not cause arts organizations to fail. The data showed that they were already teetering.

COVID just sped up the process.

COVID didn't cause entrenched arts leaders to act as though their art was more important than their community; or worse, that they could *lead* the community's tastes in the arts. COVID didn't cause donors to be held captive at two-hour lunches so that they could hear about the next season of symphonies, operas, plays, musicals, or exhibits (as though *those* were the most important reasons for support), but not the data reinforcing the idea that the underserved in the community were receiving impactful support. COVID didn't cause board members to institute overly vertical organizational charts because—and I'm sure some still believe this—nonprofits need to "act more like a business." Business gurus had something to say about that:

> We must reject the idea—well-intentioned, but dead wrong— that the primary path to greatness in the social [nonprofit/ charity] sectors is to become "more like a business."

Most businesses—like most of anything else in life—fall somewhere between mediocre and good. Few are great.
—Jim Collins, *Good to Great for the Social Sector*

COVID immediately revealed the pointlessness of arts enterprises when people are dying. Arts organizations without community impact—feeding, educating, curing, housing, protecting, mitigating harm, etc.—mostly failed. They revealed an ugly truth about the state of the industry. The US, in any case, treated (and continues, in many ways, to treat) the arts as a luxury. At best, a distraction. Certainly, not essential. Rather than improving the community impact, most arts organizations merely diversified the delivery system to the same people they drew before 2020.

In most strategic planning texts, the planning has to lead to a certain goal, which is tricky, because the nonprofit arts sector is not open to goal-setting. In fact, aiming for some moment of victory can be detrimental to the act of increasing impact.

As such, the virus stripped away the trappings of extravagance, which foment exclusion inherent in the arts organization model. With the venues and spectacle removed from the discussion (for the most part), arts organizations were left floundering for ways to show relevance in an environment where millions of people were dying. And as we've discussed earlier, when one has to proclaim relevance, one never is relevant.

Chapter 7

Art, Artists, Arts Organizations, and *Your* Arts Organization

What Is the Purpose of Art?

Simplistically put, three schools of the purpose of art dominate the conversation: reflection, transformation, and conversion, which is a combination of the first two. Shakespeare described reflection when Hamlet advised the actors in his play-within-a-play "to hold, as 'twere, the mirror up to nature." Art, in this sense, does not itself make the statement, but rather reflects the energy of the time. Reflection art almost always connotes a timeless quality.

Transformation art means to change the future. It serves as art's most powerful tool to inform, engage, and often, to compel its audience to take action. Once seen, "transformation" art—and its message—can no longer be unseen. And when action occurs, this can be a way for arts organizations to serve their community. Transformation art is sharp, fleeting, sometimes satirical, and often made obsolete mere moments after presentation. The kind of art that moves to action can cause consumers to become nostalgic about its influence—like Lorraine Schneider's famous anti-Vietnam War poster that read "War is not healthy for children and other living things"—but its power as a catalyzer wanes quickly.

Conversion art—the most powerful of the schools—combines the poignancy of reflection with the call-to-arms quality of transformation. Conversion not only moves its audience to action, but does so in a timeless way that reflects a point of view. While not intended to depict art, the anti-war sentiment of a man in front of a tank in Tiananmen Square continues to

convert audiences to sadness and anger, and as such, qualifies as conversion art in its most powerful form.

Rather than looking at programming and activities through the prism of popularity, personal choice, or risk, conversion art can offer the key to better lives at the end of this current era of societal destruction. Conversion art is not based on hope. As Vince Lombardi reportedly coined, "Hope is not a strategy." Nor is hope an activity or a goal. Conversion art offers actual ideas and the inspiration to achieve a progressively happier existence.

What Is the Purpose of Your Arts Organization?

Even if conversion art holds a purpose, arts organizations often do not. As producers (and not creators), they tend to fall back on three basic arguments for existence. These arguments are specious, at best, and purposely misleading and fallacious, at worst:

- Butts in seats
- Positive economic impact
- General increase in math scores.

These are arguments that have been proffered for almost four decades. And their arguments still haven't landed. Why? Because the results are irrelevant to YOUR arts organization. National data does not prove local worth.

The analogy is that just because schools generally offer a path to knowledge, your school should be funded. No, you need to prove that YOUR school is causing knowledge to occur.

In the case of nonprofits arts organizations such as yours, are you using national data about the arts to prove worth? Even regional data? Studies that generally depict arts participation as positive?

Or are you measuring your own, individual results, warts and all?

There are reasons that nonprofit arts organizations fail. These are among them:

- Stress
- Heartache
- Short-term failures
- Lack of control / too much control
- Bad art / bad donors / bad choices
- Badly misguided mission
- Egos
- Payroll on Friday
- No audiences
- Calls for support—straight to voicemail
- Competing against healthcare
- Competing against education
- Competing against other nonprofit arts organizations
- Making the case for art instead of making the case for your arts organization.

That last one on the list is a big one. Arts and culture organizations are consistently given tools by foundations and ivory tower consulting groups on why art matters.

But why does *your arts organization* matter? Is it because it's a "flagship"? Is it "venerable"? Does it have the biggest budget? Is the prevailing notion around the region—or within the walls of your own office—that it's too big to fail?

The arts, artists, and nonprofit arts organizations are three completely different things.

The Arts

Support the arts that move you to support them. There are a number of reasons to do so, but the case for supporting the arts is pretty clear. The arts have the capacity to engender new ideas

and inspire action—and that's reason enough to support them. Often, the purpose of art is to contextualize life in a manner that's easy to interpret. *If you want to support the arts, simply lobby for your country, state, county, city, and town to provide arts funding. Or give to your local arts agency.*

(Note: never say that the arts "nurture the soul." It's hackneyed, lazy, and unprovable. And totally meaningless. And if someone gives you that twaddle, ask them how, and exactly how many souls were nurtured last year.)

Artists

Artists do not deserve financial support just for being artists. The barrier to entry to create art is so low that it is almost imperceptible. *Anyone can create art*; ask your friendly neighborhood busker playing a guitar in front of a tourist attraction. Or your local preschooler. Selling one's art to make a living from it is a different story altogether and requires at least two parties to be in agreement. Artists deserve no more financial support than any other worker, thinker, or creator. And they deserve no less respect than any creative professional, such as an attorney, architect, engineer, or scientist.

It takes a great deal of time, effort, and failure to create meaning out of nothingness. Whether that art is visual, performance-based, or any permutation in between, supporting artists is a noble venture. The cities with larger concentrations of artists at their center, as reported in depth by Dr. Richard Florida of the Rotman School of Management at the University of Toronto, are the ones that thrive:

If you live in a city or a neighborhood that has a large concentration of...those artistic and creative bohemians then you're going to get a premium for your house and you're going to see wages and incomes rise in that community.

Even so, and this is important, it does not mean that any artist *deserves* financial support. Just because it's good business for a region to provide an environment where artists congregate, it doesn't mean that any one of those artists deserves a handout from a donor.

Should cities provide affordable housing for artists? Absolutely: it's a proven win-win. According to the US Department of Housing and Urban Development, downtown Lancaster, California's completion of the 21-unit Arbor Artist Lofts and the attendant renovation and revitalization of Lancaster Boulevard resulted in $130 million in private investment. That led to more than 1,100 temporary construction jobs, 800 permanent jobs, and nearly 50 new businesses.

Unlike a new performing arts center, housing directly supports the life of artists. Housing is an imperative for maintaining the lives of artists, not just their choice to create art. A performing arts center clearly is not.

Sales tax revenue from the downtown area of Lancaster rose by almost 100% in the first two years after the project was completed. Property values rose by 9.5% in 2012, compared with an average decline of 1.25% elsewhere in the city. Expanded downtown housing, including more than 800 senior and workforce housing units, has also bolstered the revitalization. These public and private revitalization efforts, focused on infill development and place-based investments, have led to the rebirth of Lancaster's downtown.

Should artists be *the reason* for a nonprofit arts organization to produce or present? No. That's a different kettle of fish altogether, although it goes without saying that you should never put fish in your kettle because it will make your Earl Grey smell like tuna.

Arts Organizations

Arts organizations (either commercial or nonprofit) do not deserve financial support just for presenting art, whether that art be performance-based or visual in nature. Again, the barrier to entry is minuscule — anyone can create a company to present/ produce an art piece. And many might be able to produce or present art that is of excellent quality, but we'll never know, because excellence is a subjective — and useless — term for the sector.

As we discussed in Chapter 5, just because the work you mount is of "excellent" quality (and who's to say it is — *you*?) does *not* mean you have improved your community. If you've spent hundreds of thousands of dollars on your set, eliciting applause as the curtain rises, does that mean that you've helped anyone? Do high expenses and the "best" artists equate to the most far-reaching, quantifiable impact? Or is that just another case of green grass and the Pittsburgh Pirates?

That arts organizations support artists is just part of the business. They employ them in some manner. That's not really *support*. That's a transaction: you provide this art and we'll pay you.

So, when nonprofit arts organizations point to the loss of artists in their community, they are complaining about a shrinking workforce. Not a disappearing one; a shrinking one. If a nonprofit arts leader rails to the skies about the loss of artists (or, more likely, the loss of artists that work with them regularly), know that the loss is partly the responsibility of the arts organization itself. When arts organizations successfully implement tools that quantifiably improve a community, they receive financial support. They use that support to hire, among other people, artists.

More impact, more support, more artists. Less impact, less support, fewer artists.

The Dangers of Mollycoddling

Finally, nonprofit arts organizations have created for themselves a misplaced emphasis on producing work that won't cause bad feelings. First of all, these are organizations whose leaders, especially their board members, feel that if the art produced by the organization somehow has an opinion that varies from those of several individuals in the audience (and donor base), certain Armageddon for the organization is impending.

The companies led by mollycoddling appeasers who believe that taking a stance violates the regulation against politicking, wrong again. As a nonprofit, your company cannot endorse a candidate; that's about it. But it can—and should—campaign for doing the right thing. Did you know that you can help fund a lobbying effort to increase government support of the arts? To increase government support of your own arts organization? To enact legislation favorable to the community that makes it easier for you to transform your arts organization into a proper *nonprofit* arts organization? You can. Start right away.

While leading a small company, ArtsWest, I had a cup of coffee with a supporter who had always had trouble with our mission and the execution thereof. This was not a perfect company, by any means, but a theater and gallery in a renovated five-and-dime store located in a geographically isolated business district (rather than in a downtown cathedral) in a quasi-suburb, West Seattle. It was hard to raise funds there, made harder by an inexperienced board of trustees that mostly looked to each other for money. Like many, they were loath to ask others—or often, didn't know anyone to ask—which is not unusual. Their support for the mission, however, was terrific, and their passion was on display most, if not all of the time.

A board member accompanied me on this meeting. He was sort of a loose cannon, but his social ungainliness was often charming. This was *his* connection and I was along for the

ride. We had agreed that this was not the "ask" meeting, just a meeting to inform and grow a relationship.

Of course, once we stepped into the meeting, he immediately and quite clumsily asked for money.

The donor said, "No." Right away. The board member assumed that the meeting, which had lasted about two minutes at that point, was over. He got up to leave. We hadn't even ordered coffee yet.

I asked the donor what he wanted to see.

He replied that he wanted to see meaningful work. As a World War II veteran, he had a soft spot in his heart for the musicals of that general era.

"I want to see *South Pacific*," he said. "That was the best show I ever saw."

This was a 150-seat theater with terrible sightlines, no pit, no fly space, no wings, and two communal dressing rooms. Just from a practical standpoint, there was no way we could produce the *South Pacific* of his memory. Even if we were to figure out a way to do that particular show with eight people and a three-piece combo, the result would not have led to "require conversation and improve the imagination," which was at the heart of the company's mission.

At that point in time, we were doing a controversial production of Doug Wright's *I Am My Own Wife*. The production was controversial in the sense that Seattle Rep had announced it as a part of *their* season even though ArtsWest held the rights, leading to an unfortunate (for Seattle Rep) back and forth with those who believed that whenever a large company wanted to do a play, all others should back off, regardless of which company was in the right.

We had the rights. They didn't.

Nyah.

Anyway, back to the donor. I replied to him, "We *are* doing *South Pacific*. It's called *I Am My Own Wife*."

Even the board member, coat on and ready to go, was surprised by that one.

I went on.

"*South Pacific* is a remarkable play. It won the Pulitzer Prize. There were storylines about war, love, survival, and heck, there were men in dresses."

"*I Am My Own Wife* is a remarkable play. It won the Pulitzer Prize. There are storylines about war, love, survival, and heck, there's a man in a dress."

I went on.

"It's been 60 years since *South Pacific* was presented. It was controversial. There were subjects in there that many audiences found offensive. Now, the offending parts are just part of the scenery. In 60 years, I only hope that there's a future version of you talking to a future version of me. Your counterpart will talk about that production of *I Am My Own Wife* at little ArtsWest and my counterpart will smile and say, 'We *are* doing *I Am My Own Wife*. It's called, well, whatever the title was for that year's Pulitzer Prize.'"

He ultimately didn't give us a donation, which was fine. That had been botched up front. But he did buy a couple of tickets to *I Am My Own Wife*. And ultimately became a season ticket holder, not out of loyalty to the organization, but as, in his words, an acknowledgment that the argument for presenting contemporary work was as sound now as it was in his 1940s of *South Pacific*.

In the Arts, Eggshells Are Landmines

There is no reason to avoid politics in the arts. There is every reason to embrace politics in the arts. And yet, so many don't.

When the Supreme Court overturned *Roe v. Wade*, what did your company do? Write a letter?

When George Floyd was killed, what did your company do? Insert a manifesto on your website?

There were 45,222 gun-caused deaths in the United States in 2020 (including 24,292 suicides), an increase of 14% from 2019. That number increased in 2021 by another 13%. What did your company do? Hold a company meeting?

When the Supreme Court took up the elimination of gay marriage, transgender rights, and contraception, and overturning *Roe v. Wade* as precedent for not violating the Fourteenth Amendment to the Constitution, what did your company do? Raise a rainbow flag? Do you even know that there are several different flags that represent the LGBT community?

When the president of the United States knowingly invited domestic terrorists to incite an insurrection against the government, putting democracy in danger of being eliminated, and causing the deaths of a slew of people, what did your company do? Have a moment of silence?

Did your board's finance committee spend more time talking about the bear market of 2022 than about the fact that over 600,000 people are homeless in this country, a number greater than the entire populations of Wyoming or Vermont?

Look, this is an artificially divided country, but the divisions are real. If this were 1860, another divided time, would you try to placate both sides? After all, Confederates had money, too. Still do.

Your company is not neutral. Purveyors of the arts have *never* been neutral. Take a side.

When you do, I promise that you will absolutely, positively lose the support of the toxic folks who prefer their America to continue to be a quasi-caste system. Those are the donors, for example, that believe that it doesn't matter what you do for the community, as long as they're the ones who benefit.

They'll be gone.

Good.

The arts have been, are, and will always be political in nature. That's what happens when someone takes a stand on something. In fact, it is the job of the nonprofit arts organization

to take the issues of the day, contextualize their meaning to an audience that needs it, and then use that power to make the community measurably better.

And you can't produce art while walking on eggshells. Eggshells are landmines.

Founders' Visions Are Irrelevant Because Time Changes Everything

Founders are landmines as well. Even when they're not there anymore.

Many companies, nonprofit arts organizations in particular, tend to lean into a founder's vision as something immutable. Then, when successions of successors come on, assess the situation, and see that the same obstacles to progress occur regardless of what was said at the interview by the well-meaning, progressive search committee, they either resign or get shown the door. The organization is left flailing. And when a company designed to positively impact a community of underserved people flails, the damage is real.

The only alternative—for those who would rather keep their jobs—is to walk on eggshells. When each is broken, even unintentionally, the resulting detritus of the explosion often represents the loss of impact for the organization.

"Founder's Syndrome" is an obvious issue of misplaced legacy. As time passes with any organization, change is not only appropriate; it is crucial to the impact. Sometimes, a founder may find him or herself trying to preserve the original vision and mission of the organization. "Founder's Syndrome" describes that leader's resistance to the need for change. (Note: "Founder's Syndrome" is not limited to literal founders of organizations; it can also apply to longstanding leaders, even if they did not create the company.)

No company—neither commercial nor nonprofit—can survive stasis. Nonprofit organizations, by their very charter,

have the intention to make the world a better place; by definition, the opposite of stasis.

Consider a 50-foot tall, cone-shaped pile of sea salt as representative of your arts organization.

Your organization is made up of thousands of grains of micro-processes, decisions, and parts. Each grain is dependent on the others to viably maintain its purpose. Its purpose is not forming a mound. Its purpose is to be used as a seasoning, to preserve food, or melt snow.

Time is the wind that buffets the mound of salt. As time passes, your organization changes shape in order to adapt. It might increase in size. It might decrease. Organizations are organic that way. They react to time; time does not stop to allow an organization to be formulaic in its practices.

Circumstance (both positive and negative) is water near the mound. Cumulonimbus clouds forecast, potentially, more circumstance. Water and rain might erode your mound's base, as circumstances often alter your organization's core. Similarly, the water might recede to reveal space for a larger organization. In either case, your organization must adaptively change.

Someone experiencing "Founder's Syndrome," however, might judge success by the original characteristics and goals of the salt pile they created. To that person, the salt pile is not allowed to change. If a person such as that is leading your company, it's probably time for them to go.

And when they do, *never never never* keep them around as a board member or with some title that includes the meaningless word "emeritus." The organization can never adapt to its new environment when that person is looking over the shoulder of the current leaders.

Your legacy ends the day you leave an organization.

If a leader attempts to force a legacy upon an organization, that organization will never move forward.

Identity Personalization: A Personal Nightmare

"Founder's Syndrome" is not the only landmine. "Identity Personalization" occurs at every level of nonprofit organizations, particularly arts organizations.

"Personalization," at its heart, is a good thing. A handwritten thank-you note is a great example of how personalizing a donor campaign can influence repeat contributions. Anything that can make the donor feel special about their donation's effect on your organization is an example of the positive powers of personalization. A flower. A birthday card.

"Identity Personalization" (IP) is something else entirely. A bastard cousin of "Founder's Syndrome," IP insists on stagnation in a changing world. IP can be defined in many ways, but it happens when stakeholders—and there can be more than one at a time with this affliction—have made the psychological move to believing the organization *is them*. IP causes them to believe that there is no separation between themselves and the organization. If someone argues with an organizational decision, IP causes some people to take it as a personal attack.

I know all about IP. ArtsWest had an organizational turnaround during my years there and became a player in the immediate community and in greater Seattle. I took some credit, which was warranted. It was a burgeoning organization with a lot to say. However, as the years went on, I forgot it was an organization and started treating it as a personal attachment. I had committed the sin of IP.

It was only after I left there that I recognized that I simply did not have broad enough shoulders to carry the entire weight of an organization and that by committing IP, I'd needlessly harmed myself. I recognized that I had stopped delegating responsibility. My weight and blood pressure skyrocketed. I panicked on a daily basis. I acted irrationally. I got a divorce after a 19-year marriage. I married the rebound. I divorced the rebound (source of my next book, *Don't Marry the Rebound*).

And I was supposed to be the one managing other people. I couldn't even manage myself. All as a result of IP.

I get it now. As I wrote earlier, it's part of the reason for writing this book in the first place. I may be flawed, but I want you to use these flaws to avoid your own massive landmines.

Like IP, for example.

Good Art Can't Not Be Manipulative

Many years ago, but long after I worked there, the artistic director of Seattle Repertory Theatre, David Esbjornson, proposed a series of works by Arthur Miller as a festival. There was no significance to Miller's works at that moment in time. Miller was not from Seattle. Actually, neither was Esbjornson. There was not some milestone anniversary of a landmark work by Miller.

But Esbjornson pressed on.

"Why?" I asked.

Esbjornson said that Miller was a great writer.

I agreed. Miller was a great writer. But without a connection to the community, without even a marketing angle on the presentation of Miller's plays (say, the hundredth anniversary of *All My Sons*), there was no reason to participate. If the community did not directly benefit, then my company at the time, ArtsWest, would bow out.

When I tried to gauge Esbjornson's goal with this "Miller Festival," I asked him what he wanted the audiences to *do* with the material presented to them.

He responded, rather dumbfoundedly, that you don't ask audiences to do anything, nor can you try to manipulate a response to a work of art.

I kept it in. I did not mention that the presentation of a piece of art is, all by itself, a manipulation of an audience. Van Gogh's *The Starry Night* requires a response. So does *La Bohème*. And Arthur Miller's *Death of a Salesman* actually puts the words right there in the script:

Willy Loman never made a lot of money. His name was never in the paper. He's not the finest character that ever lived. But he's a human being, and a terrible thing is happening to him. So, attention must be paid. He's not to be allowed to fall into his grave like an old dog. Attention, attention must be finally paid to such a person.

—Linda Loman, Act 1, *Death of a Salesman*, by Arthur Miller

"Attention must be paid."

You can't be more directly manipulative than that. It's a direct order to the audience, spoken through the character of the wife of the protagonist. It's the kind of manipulation that causes empathy instead of sympathy, connection instead of indifference, and a vague map of future behavior instead of amnesia.

Manipulating an audience is the core task of a work of art. Good art *can't not* be manipulative. That's another reason why neutrality cannot be a goal. It's impossible.

Is It More Important That the Need in Your Community Is Met, or That You Meet It?

I'm sure you've heard this analogy: large organizations are like aircraft carriers.

Ginormous. Unwieldy. Lots of moving parts, any one of which can sink the ship. Huge crews just to maintain operations, let alone move the carrier forward. It takes forever for a turn to be executed. It's not the kind of vehicle meant to move quickly and attack; it's a vehicle that serves as a launch pad for fighter jets that move quickly and attack.

Large nonprofit arts organizations are often tethered to their history, confusing it with their legacy. The ginormous, unwieldy quality at these organizations can be distilled into one creaky sentence.

"We do what we do because it's what we're known for doing."

(Of course, that sentence is just another version of the old, wearying "We do it this way because we've always done it this way." If a stakeholder says that to you, find them an exit strategy. Especially if that stakeholder is you.)

When your creative organization uses this justification for its programming, it not only dies a slow death, but takes the rest of the community along with it. No pretentious attempts to modernize that message will mask the fact that your people care more about your company's past (and its leadership) than about its future.

It's time to break up.

Not "break up" in the Neil Sedaka sense. Breaking up, in this sense, refers to turning your unwieldy large nonprofit arts organization into several nimbler ones.

Yes, you might lose perceived cost-effectiveness of single departments handling a multitude of tasks. But those departments have likely become bloated to handle the massive operations required to run the business. It might have already led to bureaucratic speedbumps that impede progress.

Instead of choosing to be the aircraft carrier that serves as a launching pad for fighter jets, your company could choose to be several different fighter jets, each of which attacks the region's individual problems with speed, dexterity, and agility.

What that means, though, is that you're going to have to cede a ton of your programming activities to other nonprofits—*even other nonprofit arts organizations*. It's about the living room wall being painted successfully, not the identity of the painter.

When you're a nonprofit arts organization, it's about successful impact, not the art.

How you define successful impact must be measurable, as stated earlier. Homelessness, hunger, social justice, isolation, political action—these are all issues that require addressing. If you choose even one of these problems and help to mitigate the pain they bring, you're achieving some success.

But if another organization can do it better, give them your tools and help them meet the need in your community. That's what's important, in the long run.

Bemoaning the Plight of Artists Insults the Plight of Healthcare Workers and Other Essential Personnel

By now, you've heard it, read it, and maybe even recited it. You've plugged that virtual cassette (hey kids, google "cassette") into your cerebellum and out came...

The arts are a larger segment of the economy than most people realize. The U.S. Bureau of Economic Analysis reports that the nation's arts and culture sector—nonprofit, commercial, education—is an $878 billion industry that supports 5.1 million jobs. That is 4.5% of the nation's economy—a larger share of GDP than powerhouse sectors such as agriculture, transportation, and tourism. The arts even boast a $30 billion international trade surplus.

—*Americans for the Arts*

The total nonprofit workforce at the end of September 2020 remained down by 7.6 percent from its pre-March 2020 level. Particularly hard-hit were:

- Arts, entertainment, and recreation, -34.7%
- Education, -12.6%;
- Other services, -11.2%
- Social services, -10%
- Health care, -4.3%

—*The Nonprofit Times*

Look, it's not as though this information is false. It's not false at all. It's a factual snapshot of the nonprofit sector from those moments in time.

The snapshot is just meaningless.

It's not meaningless to artists, of course. They need the work, the money, and the reason to produce art. The reason to produce art is not a money-first proposition. 99% of artists never make enough money to survive on art alone.

It's not as though there is a collection of college freshmen that suddenly see that there's money in art. And they stop coding or engineering or medicine or their poli-sci courses and have an epiphany: "Eureka! I could make so much money performing or constructing art! Why, it's a guarantee!"

Administrative artists (those that run the operations, management, and deal with the donors and boards) are a little different, but only a little. Yes, one can cobble a living working for arts organizations in that capacity. I have. But generally, it's not why people choose arts organizations for which to work. The money (except at the tippy-top, which is unconscionably high—blame the boards for that) is unsustainable, turnover is rampant, the grass is always greener in another city, and it is a telling thing that, as happens in most businesses (especially in the US), those employees with children and relationships ultimately suffer most.

The snapshot of the financial aspect of the arts is just meaningless to everyone else. Honestly, the general public doesn't care about the plight of artists. It cares about the plight of people. Especially the underserved people you're trying to help.

The core issue is one that will haunt the future of arts institutions and organizations as long as old, white, predictable, and uninspiring hangers-on still run these joints. At Americans for the Arts (AFTA), which has come to represent these folks, unbeknownst to the token cultural diversity they seem to espouse, they've even been lazy enough to try to codify the status quo.

According to AFTA's website (I kid you not)... (see chart).

THE TEN REASONS TO SUPPORT THE ARTS IN 2019	THE TEN REASONS TO SUPPORT THE ARTS IN 2020
Arts improve individual well-being.	Arts unify communities.
Arts unify communities.	Arts improve individual well-being.
Arts improve academic performance.	Arts improve academic performance.
Arts strengthen the economy.	Arts strengthen the economy.
Arts drive tourism and revenue to local businesses.	Arts drive tourism and revenue to local businesses.
Arts spark creativity and innovation.	Arts spark creativity and innovation.
Arts drive the creative industries.	Arts drive the creative industries.
Arts have social impact.	Arts have social impact.
Arts improve healthcare.	Arts improve healthcare.
Arts for the health and well-being of our military.	Arts for the health and well-being of our military.

So, other than swapping #1 and #2, there was no difference between 2019 and 2020? With a pandemic on fire? After George Floyd, Breonna Taylor, and the millions of people who have been clamoring for a new way that puts anti-racism as the one priority from here on in? After tens of thousands of annual gun deaths? After the repeal of women's rights to their own body? After arts organizations across the country have closed, will close, or are at the very least, about to close—except the big "white" institutions? Really?

> Critics say AFTA has been tone-deaf to the suffering of artists and organizations of color who have been disproportionately harmed by recent events, and it has missed opportunities to provide relief...Critics also point to AFTA's history, saying calls for equality and diversity have been ignored for years, as evidenced by the continuing relevance of its tongue-in-cheek moniker WAFTA (White Americans for the Arts).
> —*Washington Post*, December 15, 2020

Why do arts nonprofits insist on heading down the same path? Why bitch and moan, decrying the loss of jobs, the size of the industry, and some sort of bizarre "agony index" comparison with other nonprofits? The idea that somehow the plight of healthcare workers is lesser by way of some job loss percentage is insulting to the reader, an abomination to the healthcare workers, and acts as a significant, passionate reason not to support your local arts organization.

Doug Borwick, a musician who conducts workshops on effective community partnership, put it pretty succinctly: "At least one question I've seen raised about the nonprofit arts industry in 2021 is the wrong one. Roughly put, it is 'How will post-pandemic life impact us and our work?' To me, this illustrates the self-defeating 'artcentricity' that plagues us."

It's not that no one cares that artists are out of work. They care. Just like they care that their local restaurant has closed down... that the bowling alley has been torn down...that billionaires as a class have added about $1.6 trillion to their total net worth since the pandemic began.

Anyway, the whole tack of economic hardship toward the arts will not work as a selling point, just as it has *never* worked as a selling point. It does not work because it does not play with an audience. It's like a comedian explaining a joke after it bombs by talking about how his or her family will starve unless the audience laughs. Is the audience likelier to subsequently laugh?

It comes off as abrasive, insensitive, and destructive begging.

(Hint: you don't want to come off as abrasive, insensitive, or destructive, let alone all three.)

Plus, to reiterate, supporting the arts is completely different from supporting your arts organization.

Chapter 8

Leadership...Beware the Minutiae

There are a lot of books about leadership.

The first thing to remember is what Lao-Tzu wrote:

領導力是你向他人隱藏恐慌的能力。

Always remember that.

Mischief

In the mid-1990s, I worked with Edward Gilbert, one of the funniest, nicest, most gracious people I've ever known. Eddie, an Englishman whose vibe could be described as part Stan Laurel, part Derek Jacobi, and part Stephen Fry (not physically, but in the brain pan department), was the artistic director for Pittsburgh Public Theater. Before that, he had served as the artistic director for the Manitoba Theatre Center in Winnipeg for a couple of decades.

Delving into Eddie's artistic vision—not the vision of the Public, but his own personal vision—I asked him what theater's purpose was, at least to him. His response: "There are two types of places that use a preponderance of red velvet. Theaters and brothels. And what do they have in common? Mischief."

The idea of mischief has been demoted in most Americans' vernacular to mean something in which Dennis the Menace engages. It is deemed to be unintentional, a result of some series of events that ultimately inconveniences Poor Ol' Mr. Wilson.

The real meaning of mischief is far more insidious.

It's not Dennis the Menace. It's Bart Simpson.

It's not Snoopy. It's Banksy.

It's not *Home Alone*. It's *Dr. Strangelove*.

Mischief is not cute. It's dangerous.

Mischief is that which is intended to tease, mock, or create trouble. It is neither politic nor innocent. For mischief—and its sharper lexicographic cousin, subversion—to be effective, an impact must be made.

Mischief is spiking the punch. Subversion is throwing the entire contents of the punch bowl into the air, just to see what will happen.

And, interestingly, mischief is what people want to see when they go to a live event.

Haven't you noticed that audiences are more likely to talk about what went wrong (and how the actor, singer, or curator fixed it on the fly) than what went right?

In college, I performed in an inordinately over-budgeted production of *No, No, Nanette*. How over budget? The dean of the school, who directed the production, rented the Broadway set, complete with props. These props included massive, giant concrete balls on which a few dancers balanced, for no apparent reason, for about two minutes. Giant, concrete balls. You can fill in your own punchline there.

During a performance, I was in a scene where all the other actors were on the far-right side of the stage. I was all the way on the left side, placing a call on a candlestick telephone. I picked it up to place the call.

Every cord attached to that $1.99 thrift-shop phone disconnected and fell to the floor. I was holding an untethered receiver to my right ear. Then, the mouthpiece fell off the phone entirely and crashed to the floor with a loud thud. The phone disintegrated in my hands. I had to improv my way out of it.

I yelled for the maid (who was not in the scene) at the top of my lungs. She poked her head in from one of the curtains at stage left and said, in the most exasperated tone, *"What?"*

I instructed her to send a telegram to the person I was supposed to have called and gave her all the relevant information

for the sake of the plot, which was as thin as Shelley Duvall after a three-day cleanse.

The audience collectively inhaled with excitement. *That's the mischief they'd come to see.*

Think about it: do you remember the 2004 Super Bowl? Or do you remember the "wardrobe malfunction" during the halftime show?

Take advantage of mischief. Mischief is subversive, but subversion is more compelling than excellence. The arts are inherently subversive in nature.

The arts are never not subversive.

When we usually think of subversion in the arts, the immediate image is akin to what happened in Belarus in 2010, where the artistic director of the country's only free theater company was forced to go into hiding, threatened with rape and torture. There, the mere act of producing art is considered dangerous and subversive. It can get you killed.

The founding of the United States was considered not only subversive, but treasonable. The stories of Christ's teachings about supreme tolerance, loving your enemies, actively tending to the poorest among us on a daily basis, and challenging the status of those who hurt the community the most were subversive and presumably caused the Roman government to get rid of the miscreant. And then there's that White Power mob—ever-present during the entire history of the US and stronger now than it has been in decades. If they ran another country in the 1940s, wouldn't they have allied with Germany and Italy?

Even though the arts are never not subversive, one would be hard-pressed to see these qualities emanating from large- and medium-sized nonprofit arts institutions in the United States. Despite how that sentence reads, it is not the fault of the arts institutions per se. They are governed by

sensible board members who hire...

politic arts administrators in order to produce...

safe productions and exhibitions that will suck up gads of money from wealthy, shrewd corporations, individuals, foundations, and governments...

in order to continue...continue...continue doing that thing they do, whatever that is.

To be fair, there are moments of mischief, to be sure. For every 8,949 performances in the original run of *Cats* on Broadway (hardly a mischievous play, despite its cast of, well, cats), there were 367 performances of the original run of *Angels in America* (a play that proffered targeted ideas about AIDS, homosexuality, pain, the definition of family, and wonder in the most subversive of ways). So, using totally inane illogic, there's a 4% chance of impactful mischief on Broadway.

The new normal in the arts has to center on mischief. Mischief is a key ingredient to social change. If there were no mischief—in essence, if people didn't think anything was wrong—nothing would get better. The arts have the tools to engage people in accepting change.

Once seen, *Angels in America* cannot be unseen. It is perhaps the best example of conversion art in the past 50 years, theatrically speaking, spurred on by its sense of mischief. Its issues cannot be dismissed as not having happened.

Once heard, Henryk Górecki's Symphony No. 3, a contemporary classical orchestral and vocal work that evokes the sadness and futility of the Holocaust in Poland, cannot be unheard.

The same holds true for seminal visual art such as *The Scream*.

Some might say that a Laurie Anderson concert can evoke that same sense of mischief. Or Bad Bunny. Or Beyoncé. And they're not wrong.

The Irony-Free Police, Tight and Loose Cultures, and the Road to Hell

There are members of a relatively new movement that a good friend of mine calls The Irony-Free Police. The IFP has gotten a toehold—well, maybe a foothold—in arts leadership. There is an extreme amount of serious seriousness and earnest earnestness fueling this group's wacky campaign to stamp out any vestige of humor and context from all performance forms. Also known as the Trigger Warning crowd, their movement is the character and value equivalent of putting the Declaration of Independence through spell-check.

The IFP movement is well-intentioned, like all highways to Hell. Thoughtfully, they have revealed that many individuals in our society, no matter how well-heeled or well-educated, have prejudices that are mean-spirited, hypocritical, or dangerous to humanity. They're not wrong.

What the IFP seems to forget is that we already knew that.

To delete these prejudices or hypocrisies from protagonists in theater, opera, ballet, or the visual arts reduces the meaning of the work to befit the IFP member. Which, now that I re-read that sentence, is a dangerously elitist way of thinking, isn't it?

The IFP have become prominent enough that they have cynically collapsed the power of the arts to hold meaning. Meaning is everything, when it comes to the arts, but it is like a balloon, best when full but easy to pop with an easy, pointy barb.

Leaders of nonprofit arts organizations have a mandate to create meaningful art because only meaningful art can be used as a tool to make the community a better place. Meaning is totally subjective, of course, and depends on the "tightness" or "looseness" of the environment in which the nonprofit arts organization works.

"Tight cultures," according to Michele Gelfand in her impressive study called *Rule Makers, Rule Breakers*, "have strong

social norms and little tolerance for deviance. Loose cultures have weak social norms and are highly permissive."

Leadership in a tight community, one that craves order and a paternal governing body, often requires an autocratic hand. Gelfand writes that

> after the crumbling of the oppressively tight USSR in 1991, 51 percent of Russians supported democracy...only 39 percent supported a leader with a strong hand. By 2011, however, there was a huge pivot: 57 percent of Russians supported a ruler with a strong hand [Vladimir Putin] and 68 percent were in favor of state interference.

The intervening 20 years between 1991 and 2011 saw Russians' economic life crumble, inflation skyrocketing, and oil prices plummeting. For the tight community that was suddenly (and unexpectedly) freed, the yearning to "Make Russia Great Again" was palpable.

If your arts organization is in Alabama, for example, you are working in a relatively tight culture. Social norms show little in the way of tolerance. Mischief is not only considered dangerous; it can also get one killed, either via militaristic threat or by vigilante norm-following, especially when it comes to the divide between white privilege and Black repression. One group of people has a distinct advantage in life over the other group of people, and the controlling group is loath to cede that unearned power. And there are still those among the repressed that accept intolerance because it is familiar to them. And because it's safer to defer instead of protest.

One day, in downtown Montgomery, I walked on the sidewalk to a meeting. An older African-American man walked toward me on the same sidewalk. Seeing me, he took off his hat and walked off into the gutter. I reached out to help him back onto the sidewalk. I told him that he never had to walk in the

gutter just because a white man was approaching. He smiled and said, "Y'all ain't from 'round here, are you?"

Ironically, this incident took place directly in front of the Rosa Parks Museum.

The repressive nature of Alabama requires its artists to use subtlety in the quest for change and improving the lot of its citizenry. But even the most subtle of change can be construed as dangerous. If a way of life is threatened in Alabama, the response is tightness. Change, on some level, can be seen insulting to those currently in power.

My development director at ASF (Alabama Shakespeare Festival) once asked me, in total wide-eyed honesty, why I continued to talk about making Montgomery a better place to live.

"Isn't it good enough just as it is?" she asked. "Some folks think so."

If you are used to leading within a tight culture, a shock of awakening is in store for you when you are asked to move to Seattle, a mostly loose culture. The "Seattle Way" is a popular term that describes the circular route most planning takes on its route from "idea" to "law" (if it ever gets to that point, which it rarely does). As Ted Van Dyk once wrote in the *Seattle Post-Intelligencer*, "The 'Seattle Way' usually is defined as circular consultation reaching indecision. But it also consists of an uninvolved electorate and public decisions taken carelessly, without regard for experience elsewhere and unmindful of consequence."

A 1983 editorial in the *Seattle Weekly* described the "Seattle Way" as "the usual Seattle process of seeking consensus through exhaustion."

To the astonishment of people from tight cultures, the marches that decried police brutality on Black people in Seattle evolved into a territorial annexation of the area surrounding the police station in the Capitol Hill neighborhood. The city had

originally tried to disperse the groups with the usual armaments (tear gas and rubber bullets), but the protestors did not waver in their determination to change the way in which Black people were treated by police.

The city's leaders, using a great deal of input from experts on crowd control in such instances, saw two options at their command: a) fully attack the protestors, probably killing many of them, to force them to retreat; or b) create a "safe zone" for the protestors where they could act out with damage contained to a certain area. They chose the second option, calling it the Capitol Hill Occupied Protest zone, or CHOP zone. It was a wise choice, in hindsight; the first option would have invited similar (or perhaps more violent) protestors to fight, killing far more people.

The "Seattle Way" is not limited to governmental decision-making. The chief characteristic of the "Seattle Way" as it pertains to nonprofit arts organizations is the tendency to expect that every person must have a say in every single decision. In extreme cases, it can mean that one person offended by a decision might permanently waylay its implementation.

In Seattle, there are meetings about meetings just to set the rules of engagement about how a spreadsheet should be presented at, you guessed it, yet another meeting.

In the arts in Seattle, there are benefits to changing gears quickly. Perhaps it is the tech industry that has affected the arts (or perhaps the arts have fed the tech industry), but failure, in some ways, is seen as the natural result of innovation. Without regard to job title or even department, all are asked to question, provoke, self-express, and reinvent the organization on a regular basis. Challenging why something is done is the hallmark of a loose organization, especially if that thing has been done for longer than anyone can remember. Wide input is sought out and welcomed, even in an industry where strict deadlines exist. In the parlance of a theater company, everyone is on time for

Opening Night, but the path to get there is different with each production.

Quickie #3

How does all this affect impact?

In the broadest of senses, it doesn't. A good nonprofit arts organization, whether it's in Montgomery or Seattle, has the same goal: to utilize tools to make its community better. Help the homeless get off the streets. Mitigate hunger. Solve traffic. Narrow the wage gap. Utilize the diversity and skill brought forth by cultures that have not had the same opportunity to tell their stories.

What *does* change is the method by which impact is brought to bear. That's why there is no "one way" to present this information. Just as you will look at this book and determine what works for you and what doesn't, your community is looking to you for ideas on what will solve its problems and what won't.

The only thing that applies to both tight and loose communities, as regards its nonprofit arts organizations, is that the mere production of art is not enough to change the outcomes for people in need. And the impact your community *deserves* requires you to accept that core truth.

Build Your Arts Organization Out of Stone, Not Ephemera

The aforementioned Eddie Gilbert owned an Italian farmhouse. The walls of the family room were stone, both inside and out, built by hand 600 years ago. Eddie was talking with the local handyman of the village during the first spring his family was there. One entire interior wall was soaking wet.

"What am I going to do?" Eddie pleaded.

"Turn around," said the handyman. Eddie obliged, looking now at the dry, opposite wall.

"See? Everything's fine."

The handyman wasn't being glib or averse to doing work. He just knew that when a structure gets wet during each spring because of rain, snowmelt, and runoff and it still stands strong after 600 years, another year of a wet wall probably isn't going to bring it down.

If your nonprofit arts organization is built on a structure where the point is to make a quantifiable positive difference in the lives of the people of the community...

if the mission makes that point clear...

if the people on staff (including the artists and board) keep that mission in mind every minute of the day...

and if benefactors understand that their role is to support (and not to benefit)...

If all that happens, there is no environment in which your company cannot succeed.

If, however, you do art for (*blecch*) "art's sake"...

if you do art trying to either lead or follow the tastes of the stakeholders, as a commercial arts organization does...

if your mission statement is either a declarative description of your activities with no larger goal in mind than "excellence"...

and if your benefactors control the programming with their dollars...

If all that happens, almost anything will knock it down.

What If You Knew Exactly When Your Nonprofit Arts Organization Was Going to Close Down?

How would your charitable activities change? Or would they?

The *Seattle Times* reported in 2022 that a new transit station set for the Seattle Center grounds might endanger the existence of several of the nonprofit institutions situated there. Seattle

Center is the 74-acre home of dozens of major arts and cultural organizations. And something called the "Space Needle."

While the long-awaited train station is scheduled to arrive in 2037, the digging for said station will take five years to complete. The station's construction—and, it would appear, its general use—would not only disrupt a slew of the current Seattle Center tenants, but might put their organizations out of business.

If construction starts in earnest in 2032 and deals an existential threat to Seattle Rep, the Vera Project, and KEXP radio, what are the next steps for those organizations?

You can discuss the relative merits of introducing a badly needed transit system against those of the nonprofit organizations that would be uprooted. However, that decision had already been made by the voters.

This is not about that.

Instead, let's discuss death, shall we?

If it were guaranteed that in ten years your nonprofit arts organization would be closed for good, how would that affect your activities?

Do not confuse the answer by anthropomorphizing your organization. It is not a person who is dying. The question at hand is not what *you* would do if *you* knew that *you* would die in ten years. This is about your nonprofit arts organization.

The answer to this question has to emanate from all the stakeholders of your organization, including the board, staff, and audience—and all the unaffiliated community members.

The question, you see, is equivalent to the question of why your nonprofit succeeds in the first place. Or does it succeed? How would you know if it does?

This reality may well be coming for those Seattle Center nonprofits. What will they do? That's yet to be seen. They might

try to exploit the "Seattle Way" to delay the inevitable. They may move. They may close down (no shame in that).

The key here—moving past the minutiae involved in the day-to-day aspect of any company—is that an existential threat can be an opportunity to focus on one thing: impact. Once your nonprofit arts organization can prove that you have *literally* helped members of your community, it becomes indispensable. And no amount of construction can keep you from doing that thing the community wants you to do—why they allowed you to be a charity in the first place.

If you *have* to close in ten years, be truthful to your own organization and to your community about your indispensability. Here is the key question that can help you identify that:

> *If our organization is measurably making lives better for those that cannot make it better for themselves—the center of nonprofit worth—how will that continue after the organization is gone?*

The Tortoise and the Hare and the Ants, Not by Aesop

Do you remember the Aesop fable, *The Tortoise and the Hare*? The tortoise wins the race, right?

My version of the story is called *The Tortoise and the Hare and the Ants*.

And in human form, all three play key roles in the race. The tortoise, who works methodically in his own interest; the hare, whose real goal is to be seen as a hero; and the seemingly insignificant ants, who, individually, have thoughts neither of personal interest nor of glory—they just get the job done. As the story begins, neither the tortoise nor the hare take much notice of the ants.

One day, the animals in the forest took note of some key problems that they needed to address. Among them was that a key pathway from the trees to the water had become polluted

with all sorts of dead plants and wood shavings that the beavers just left behind when they built their dams.

Beavers, am I right?

But now there was a problem that had to be solved to keep the ecosystem alive. The hare darted around, saying he had a solution that could be solved by running back and forth through that blocked path. He suggested that his speed, valor, and derring-do would be able to clear that path.

The tortoise noticed that the blocked path served his needs, because it blocked animals that eat tortoises from entering the forest. He thought all the animals should meet, break up into groups, and talk about the problem. He also blamed the hare for bringing up such a, well, hare-brained solution, saying that he and his fellow tortoises could not support it. The animals, who trusted neither the hare nor the tortoise, still had their problem, but were now bored by the whole situation.

Tortoises crave boredom. They use it as a useful tool against the better angels of our society. There are even those who say that Senator Mitch McConnell has spent so much of his career as a tortoise that he's begun to resemble one.

The tortoises used their energies to gum up all processes in order to get their way. Instead of solutions, they sought obstruction of others' solutions. They believed that there was nothing better than the status quo, because they thrived in non-action.

They wanted to do away, for example, with arts funding, because they believed the arts provided something dangerous to society. Further, they saw nonprofit arts organizations as easy targets. Arts organizations were often led by flashy hare impresarios instead of strategic leaders. It was easy to distract them by just threatening to negatively affect arts funding. They enjoyed watching the arts leaders freak out.

You run one of those nonprofit arts organizations. You put on programming that people love. You've weathered a pandemic, or at least survived it. And just a few months ago, after George

Floyd was murdered by a police officer, you wrote a diversity manifesto—heck, you've probably even hired a DEI director. You put out a press release and everything.

But now, you think the pandemic has subsided. Finally. Using a resentment-fueled sense of artistic freedom (because your creativity was unceremoniously stifled for too long), you feel you *deserve* to do that symphony, that musical, that play, that exhibition (etc.) that you have *always wanted* to do. You want adulation. You want fame. You want to be an art hero. You want to be a community hero. You want to be a hero to the forest.

In my version of the story, if you're like that, you're the hare.

Tortoises love hares. They adore people who aspire to be heroes. Fame is fleeting, to be sure, but more than that, for nonprofit arts organizations, fame is irrelevant. More than even that, fame is inappropriate. That's why tortoises are never heroes, only pragmatic saboteurs.

"But wait," you say, "I'm not alone in my thinking. Look at these copies of *American Theatre, Symphony, ARTnews, Dance,* and *Opera News*," you shout. "Here's an article in the *New York Times*," you scream. "All of these publications celebrate the work of great artists, and the ambition to be a great artist only helps my organization become better known and better supported."

As a hare, you're touting artistic adulation as impact, not your organization's effectiveness as a charity. It's a form of "whataboutism" that speaks to factors outside the real issue.

Tortoises love it when ambitious people use "whataboutism" like this. It is a tacit admission that you and the other hares are not achieving any real impact on society.

"But," you chirp again, your nose twitching wildly, "my goals as a nonprofit arts director are intertwined with the goals of my company. What about all those other artists getting attention for their work? Why is it wrong to be one of them?"

The tortoises will be among the first to cheer you on, even deliver energy-sapping, wholly hollow arguments against you

to buffer your resolve to be famous—I mean, to be a forest hero. They'll make it look like you achieved a victory when $162 million is devoted to the NEA (National Endowment for the Arts), even though that's just couch change for this country's budget. They love that you spend your energy on something so minuscule in nature.

As a hare, do you see the NEA as a potential for a new source of revenue (for your company, and by extension, for you)? Is that why you support it? Do you believe that presenting that symphony you always wanted to do will bring about positive impact for your community?

Back to the story. The tortoise hated real impact by other species, especially the hare. The tortoise did not believe he was being an obstructionist. He merely believed he executed real impact—in his own interest.

The hare quickly whipped around the forest showing the woodland creatures how much better life would be if they would only follow his lead. The other animals agreed with the premise that the hare wanted to help clear the path. But they were also persuaded by the tortoise that the hare's ideas didn't really supply any help for their little ecosystem. They experienced analysis paralysis and stopped working on the problem, even though it still existed for them.

Just then, a colony of ants used their collective effort to upend the tortoise. In doing so, they provided indispensability to the community. They'd become a political force, not merely from producing a piece of art, but by fulfilling societal needs in new, creative ways, using art as the tool (and not as a finished product).

The tortoise, now on its back, became disoriented. It could not see clearly. Ultimately, it lost perspective and flailed helplessly.

The ants didn't have to worry about the hare, because he was still running and jumping around the forest seeking adulation for the work he'd done to defeat the tortoise.

The woodland creatures happily gave the ants some portions of their food in order to keep them alive. They celebrated the ants' indispensability as a part of their ecosystem. The ants, in turn, created tunnels and routes that cleared out the beavers' detritus. The pathway was clear. The forest creatures thrived once again.

Except the tortoise, of course, who was left powerless. And the hare, who was ignored by the other creatures for claiming credit for something he hadn't done.

The ants might be your nonprofit arts organization, if you choose to provide impact ahead of art.

When egos and motives get entangled with impact, the community cannot thrive. Your task as a nonprofit is the opposite of that. As long as you're doing the tasks necessary to make your community an increasingly better place to live—like the ants did—it doesn't matter what others think of your work. Stop worrying about the art critics and fame; just get the work done.

One tortoise will beat one hare every day of the week. You don't want to be either one. You want to be the ants working together to help the ecosystem.

Oh, Okay. The Lao-Tzu Quote

"Leadership is your ability to hide your panic from others."

I have panicked numerous times. I have had pneumonia at least six times—all as a result of hyperstress, overwork, and panic.

Leadership is hard, especially when the lack of money is a glaring problem. The pressure of making the right decision 100% of the time can cause you to do things that you would never have done in a quiet moment. It's easy to panic.

Leadership in this particular industry can often be made difficult by the very nature of artists. Artists, unlike many

engineers, architects, and other creative professionals, have myriad motivations to succeed, sometimes all swirling around at once. As the leader of an organization that uses art to make a community healthier, it is your job to boil down all the drama, so to speak, to become a collectively effective force. And that takes quite a bit of energy and speed, which can create more panic.

But Lao-Tzu and I just want to remind you: if you think you're the only one panicking, you're wrong. At some point, all leaders panic; the only ones that don't are oblivious, stupid, or dead.

Chapter 9

Things You Can Do Right Now

Throughout the book, we have talked about the idea of turning your nonprofit arts organization into a force that quantifiably helps your community become a better place to live. In this chapter, we'll give you some examples of companies doing just that. And we'll talk about theoretically sound ideas that might spark something in you.

Because every nonprofit arts organization has a different budget, exists in a different ecosystem, and possesses a different set of leaders prioritizing the issues on which you want to focus, there is no one-size-fits-all answer to your own nonprofit's task of helping your community. No matter what some MFA class might have taught you.

With that in mind, do you believe that all nonprofits make a good-faith effort to make their communities a better place to live?

One would hope so. That's the whole point of the nonprofit sector. The sector makes communities better in seminal ways that the capitalistic sector has deemed unprofitable.

Feeding the hungry, housing the homeless, banning animal cruelty, getting guns off the streets. These are the kinds of unprofitable, non-capitalistic issues that require a nonprofit to step in, receive some tax breaks (both for themselves and for their donors), and solve.

Results are quantifiable, actionable, and show communities getting better. It's about data. It's not about some gut feeling or roundabout tale of undocumented inspiration.

Good data proves good faith.

Does Your Nonprofit Make a Good-Faith Effort to Make Your Community a Better Place to Live?

In Minneapolis, Mixed Blood Theatre does exactly that. They have established a longstanding good-faith effort. Take a look at the mission and gauge it for yourself:

> Mixed Blood uses theater to disrupt injustice. We are a social justice organization catalyzing action and change through art. Our work is guided by deep community engagement and rooted in radical hospitality.

"Radical hospitality" is a fascinating phrase. If you research it, you'll find dozens of examples of its use as an interpretation of Christian doctrine. In Matthew 25:35–40, Jesus praises those who offer hospitality to the neediest in society.

> For I was hungered, and ye gave me meat: I was thirsty, and ye gave me drink: I was a stranger, and ye took me in:
>
> Naked, and ye clothed me: I was sick, and ye visited me: I was in prison, and ye came unto me.
>
> Then shall the righteous answer him, saying, Lord, when saw we thee hungered, and fed thee? or thirsty, and gave thee drink?
>
> When saw we thee a stranger, and took thee in? or naked, and clothed thee?
>
> Or when saw we thee sick, or in prison, and came unto thee?
>
> And the King shall answer and say unto them, Verily I say unto you, Inasmuch as ye have done it unto one of the least of these my brethren, ye have done it unto me.

In terms of Mixed Blood Theatre, how does this anti-elitist idea manifest as charitable action with measurable goals? By

not only allying its artistic programming with the members of the community, but also producing art that is *sought out* by its members.

Instead of finding and sharing stories we deem topical, our guiding principle is "We want to be part of your story." Through theater, we connect people and organizations to advance dialogue on an issue, inspiring civic discourse and a sustained call to action.

Mixed Blood Theatre provides no-cost admission for anyone. Anyone. Their art is not for its own sake; instead, its purpose is to create an audience and community of people who otherwise wouldn't be involved in theater and the arts.

Beyond no-cost admission, Mixed Blood also offers free transportation and a fully accessible building for those with disabilities. The company produces art as a tool to promote civic engagement in creating healthier families and communities.

It is imperative that the arts never be deemed not essential again. We must infuse ourselves into social equations, such that those social equations cannot be solved without the arts.
—Jack Reuler, Founder, Mixed Blood Theatre

Nonprofits Are Scientific Experiments. Experiments Require Data

In a capitalist society such as the United States, is there value to charity? After all, the services offered are unaffordable to the users of that service.

Does each community want to pay for such services, even when the services do not directly enhance them?

Is your nonprofit organization, chartered by the state in which you practice your services to help people, the most

effective way of dealing with a particular set of issues that plague some members of your community?

One of the best ways to analyze your activities is to subject them to the Scientific Method, a process for experimentation that is used to explore observations and answer questions. There are some fixed steps to this kind of scientific analysis, but its use can absolutely be translated to your nonprofit arts organization. If you've forgotten your high school science class, here's how the Scientific Method works as it applies to your nonprofit arts organization.

Following this explanation, we'll show you a sample of how it might work for you.

Step 1. Ask a question
Samples: How is your nonprofit arts organization helping the community? How can you make your work meaningful in ways that a profit-making venture could not? What would be the best charitable impacts you could make for your community using produced or presented art as a tool?

Step 2. Do research
Have no preconceived notions. Uncover exactly what your current services do. Uncover what they were meant to do. Get as much data as you can, and study it. All data is important; do not dismiss any data that conflicts with the results you may want. Do not jump to a conclusion based on your data collection. Stay in your research lane here.

Step 3. Construct a hypothesis
Compose an educated guess about each answer to your question in step 1. Then construct a prediction based on that educated guess. A good way to think about a format for a hypothesis is this: "If we do X, then Y will happen." Note that it doesn't

say "If we do X, then Y *might* happen." This is not a wishful-thinking practice, because you'll need your data to back up your hypothesis.

Step 4. Test your hypothesis
Using the data at hand, test your hypothesis by doing an experiment. This is what we mean by "nonprofits are experiments." There are no pat answers; in fact, you may discover that your purpose as a nonprofit has great, medium, little, no, or even a negative effect on your community. For data to be fairly evaluated, you will need to be as clean as possible with your activities and evaluate them for what they do, not what you want them to do. Or what you *believe* they do.

Step 5. Analyze all the data and results, and draw a conclusion
Was your hypothesis supported by the data? Was it proved wrong? Don't put your thumb on the scale and draw a conclusion based on a preconceived notion. Be completely impersonal about the effect your nonprofit arts organization has on the community. Look at everything. Discover the level of effectiveness that can be read by your data. Was there a change in thinking? Were there unintended consequences? This is a hyperbole-free zone. No exclamation points, please.

Step 6. Communicate the results
In official form, publish your results. If supportive to your cause, you'll have something concrete to use as a reason for people to fund your work. If unsupportive, you'll have something that will let you know what things you need to either do differently or stop doing entirely in order to maximize your impact.

Note: repeat all the subsequent steps for each question you ask in step 1. And within each question, repeat steps 4, 5, and 6

every single time you have a new hypothesis. Each hypothesis deserves its own analysis and its own report.

All this takes time and a lot of analysis. All the tasks can be delegated to consultants, of course, and might even bring you a better sense of the feasibility of your organization if they are truly independent thinkers not directed to draw *your* conclusion. In other words, don't ask them to come up with an answer but invite them to be as baldly analytical as they can.

If you don't believe your nonprofit arts organization can withstand the scrutiny of data collection, you might ask yourself why a donor would support you without evidence of impact.

Or do you think that your company can't have the kind of community impact that helps disadvantaged people? There's a Henry Ford quote about that kind of thinking: "Whether you think you can or you think you can't, you're right."

Of course, Henry Ford was an antisemitic Nazi sympathizer who makes John D. MacArthur look like a boy scout, so maybe he's not the right guy to talk about community impact.

Scientific Method Sample

Let's try out the scientific method for a hypothetical intention by your nonprofit arts organization. As I write this, I have no absolute knowledge about how it will come out. That's important to the scientific method.

It also may be completely wrong-headed. That's okay, too. Work with people who are experts at the issue you're conquering, but know that every idea does not apply to your nonprofit arts organization. Also know that some ideas *only* apply to *your* nonprofit arts organization.

Do not set up conclusions to be met; rather, go all the way through with the method to see what conclusions you might be able to draw—if any—in the fifth step. Setting up conclusions is a kind of wish-fulfillment. It's not real, nor is it of any use to the scientist.

Remember, this is a *sample* of how the scientific method works in getting you to your impact goals. The question used is for illustration purposes only. Yours will necessarily be different, in that it will apply specifically to your arts organization, your community, and your community's explicit needs.

Step 1. Ask a question

- What would be the best social impacts we could make for our community using produced or presented art as a tool?

That's it. You're already done with step 1.

Step 2. Do research

- In my community, the most perilous conditions affect the Black population.
- They are continually harassed by police (and here are the statistics).
- They do not get jobs for which they are qualified (and here are the statistics).
- They are paid less than their white counterparts (and here are the statistics).
- While growing up in public education systems, they are suspended and expelled at rates ten times that of other students (and these are the statistics).
- That punishment cycle leads to feelings of inadequacy and expectation of bad acts (and these are the statistics).
- Because of the undeserved notoriety of Black people in my community, people of other races are scared to be around them (and here is proof).
- Because of that fear, Black people are less likely to be hired for entry-level positions, even when they are qualified (and here are the statistics).

- Even when a Black person is given a position of power, many other leaders see them not as leaders, but as angry threats to the community (and here is the proof).

Do not be skimpy on the statistics — this is research, not guessing.

Step 3. Construct a hypothesis

- Hypothesis: If we include a Black community perspective on *every* single production we offer, regularly integrate the stories of Black people in our own community with stories of other races and ethnicities, and find ways to divert highly needed financial resources to Black-led and Black-focused nonprofit organizations, we will succeed in raising the level of life of the Black people in our community by at least 50%.

It's always better when you come up with a big, meaningful hypothesis with a big figure at the end.

Aim high. If you aim for a 6 and get a 6, what kind of achievement is that? However, if you aim for a 10 and get a 6, you gain the motivation to work harder on your programs.

Step 4. Test your hypothesis

- Working with the executive directors, boards, and staffs of Black Nonprofit Organization #1 and Black Nonprofit Organization #2, we will ensure that no fewer than 75% of our seasons are comprised of events to lift every member of our particular Black community. To show our seriousness toward that end, we will ensure that 100% of the next season is comprised of such events.

- We will look at our own organization and make sure that all of our payroll information is transparent and shows equity all around.
- Black people were previously excluded because they were not networked in to the longstanding white community embedded in our organization. We will hire qualified Black people from our community to posted positions, even if a white candidate has a tie to our board or other staff.
- We will send 50% of ticket revenue to be split between Black Nonprofit Organizations #1 and #2. In exchange, they will provide educational and societal programs to our constituents.
- We will send 50% of the seats to these productions to people in the community who have been identified as underserved or in need, including Black people, white people, and others, so that they may understand the motivations of the Black people in our community. These tickets will be free of charge to the user.
- We will identify those donors, staff members, and board members in our own system who are loath to support Black causes, and either offer them the chance to join us in raising the playing field for the Black community, or offer them an exit strategy.

Each one of these items might be its own separate test. It's up to you to decide how best to manage the process and get the results from it.

Step 5. Analyze all the data and results, and draw a conclusion

- Black unemployment went down X%.
- Y% fewer Black men and women were stopped by police officers.

- Black people in our employ were paid exactly the same as white people.
- Pay inequity shrank community-wide by Z%.
- Black youths in public schools are punished at the same rate as other youths (and here is the data).
- There are A% more interracial social and business groups in our area, easing fears among the races, at least in our community (and here is the data).
- Black leaders are followed or dismissed based on their actions, not the expectations brought on by the color of their skin (and here is the proof).

This is, by no means, an actual scientifically drawn issue. There is no data, no results, and only general notions of equity and inclusion presented. Your scientific method should be more detailed, of course.

But notice that there are no artistic goals listed such as "excellence," "talent," "quality," "highly acclaimed," or even the word "artistic." They are incidental when you're trying to solve a problem that plagues your community. They have no business in your strategies, either.

Good Faith

A "good faith" effort in a nonprofit is predicated on two ideas: a) there is a societal problem within the community that requires solving by a non-capitalist organization; and b) there is a measured, quantifiable goal that either eradicates or mitigates that same issue.

Let's say your community has a superabundance of mentally ill people who have been discharged from underfunded government services and left homeless. Builders have not built structures to house them because the builders required a profit-making scenario.

That sets up the first half of the good-faith effort: a) a nonprofit steps in and raises money to convert existing buildings to house homeless people, help treat them for the traumas they have endured, and provide them support to get their lives together.

The nonprofit then sets up the second step: b) its program directors measure the number of mentally ill homeless people in a particular community, gauge through research why they are homeless, and measure the success of their support services by quantifying the number of people served, the number who become housed, and the number of people who "graduate" from the program. As a result, the homeless population shrinks and the people who go through the programs of the nonprofit ultimately become self-sufficient and healthier.

Solving the external problem has to come first. Then a good nonprofit strategizes the second part. Good-faith efforts require that to happen in that order.

Sadly, almost all nonprofit arts organizations—at best— try to do this in reverse order. They'll put together programs (performances, exhibitions, etc.) and then backfill a mission to prove worth. Some use the backfilling process merely to hide behind the cardboard shield that producing plays, musicals, symphonies, operas, etc. solves a societal problem of not having plays, musicals, symphonies, operas, etc.

That's like saying that Mars, Incorporated fulfills its nonprofit mission by making M&Ms because it solves the societal problem of not having M&Ms.

Without that core element of an identified social problem in a community leading to an answer, many decry arts organizations as tone-deaf to the issues of the day. Instead, they are seen as concentrating their efforts on their own survival, the plight of artists, and the obstacles to production.

You have to pull the whole organization apart like fresh challah and ask, "Why are we necessary?" Then, plan every action used for building that vehicle to answer that question.

If you are a leader disinterested in your community's needs except as they fit your own artistic vision, you are a failing nonprofit leader. Please don't take this the wrong way, but you might want to resign, which your real stakeholders would applaud. Loudly.

Alternatively, you might consider changing your organizational structure into a commercial business, with investors and other financial stakeholders. There is no shame in becoming a for-profit enterprise, and while taxes are higher, so are the potential returns.

If, however, something has nagged at you for years about the purpose and drive behind the production of your version of art, and what good your community derives from it, act on that impulse to change. Stop everything and build your business model to fulfill the need of the community instead of the need of the artists, staff, or board.

How to Hire Great People (and Avoid the Pitfalls of "Cultural Fit")

Hiring practices are, at best, broken. At worst, they are salacious and evil, practicing horrible ethics and actions on candidates and employees.

And it's not even that hard to do the right thing. That's perhaps the saddest part.

Are your hiring practices evil? They well may be.

Even if your company's hiring practices are "industry standard" (by definition, middling), then its values are equally unimportant, no matter what greatness your company ostensibly performs. Here's the best way to hire someone:

- Post job.
- IMMEDIATELY upon receipt of job application, respond to applicants with receipt in the manner they applied (email for online, postcard for mail).

- Hiring Managers: Compile three categories (Yes/No/Maybe).
- If you have more than three applicants in the "Yes" pile, move "Maybe" into "No."
- Inform "Nos" of status.
- Interview "Yeses."
- Inform new "Nos" of status.
- Final interviews.
- Hire.
- Inform new "Nos" of status.
- And whenever possible: hire someone better than you.

And you'll want to get buy-in—but not decision-making buy-in—from a few of your office colleagues. Or maybe the person to whom *you* report. And, of course, you'll check references and do all the legal activities you must do.

I know this sounds simplistic. It's not simplistic; it's merely simple.

Hiring has become complicated, in part, because HR professionals and search firms choose to make it complicated. Perhaps they see the process and jargon as job justification, much like tech support people and attorneys are wont to do.

HR professionals and search firms choose not to fight battles, seeing themselves as the loser in that gambit. They may choose to suggest, cajole, and hint at ideas to help, but they have little stomach for losing work over a little thing like illegal, immoral discrimination.

Does this image represent your current hiring process?

Even nonprofits who recently have issued manifestos regarding their newfound cultural sensitivity and anti-racist policies have quietly kept their hiring practices exactly the same as they ever were. They lack the imagination to show that a qualified candidate is not necessarily the one who had exactly the same job title as the departing employee.

After all, these nonprofit arts organizations reason, isn't it easier to choose someone who has already done the job, regardless of their privilege? Isn't it easier to hire someone the same age—or rather, the age of the predecessor when they were hired a few years ago? Same color? Same access to education? Same circle of friends?

You see where this is going. It's not pretty.

And if you don't even notice that your talent pool is appallingly similar—white, childless, 30s–40s (35–45 for an executive director), good school, ready to work 168 hours a week, and the only reason you're looking at women is that a) your pay is below market value (and you wouldn't trust any man who deigned to accept that paltry salary); b) you feel that you can control a woman more than a man; and c) you have "binders full of women" (see Mitt Romney, 2012) to satisfy your foundation funders—then please fire yourself immediately. Move on. You don't get it. You probably never will. Sad, really, because your organization has suffered because of it.

So, why is equity hiring so difficult? It's not. You may have made it difficult if you are not willing to change the way you do it. Simple as that.

It doesn't matter if you take all the anti-racism courses. It doesn't matter if some of your best friends are _____ (fill in the ethnic/gender/age discriminatory noun here). It doesn't matter if you've issued a formal statement supporting diversity and cultural rights. If you don't drastically change your hiring practice, you will only be pulling from the clones of the people you have now.

I saw a sign once that read: "Change is good. You change first."

Do it. Make changes. Big ones. It's the right thing to do.

- Never be the smartest person in the room. Hire candidates who are better than you. If you can't, you're likely a terrible person to work for. You've let your ego run the show, which means you're also likely terrible at delegating tasks. Your trust capacity is limited.
- Make clear what the goal is. In nonprofits, that goal is defined by the charitable mission, which in turn is defined by the community need. If it isn't, your mission probably stinks. Write one that comes from the gut, in plain language. As an old professor used to say to me, "Gun to your head, why are you here?"
- Using *their* strengths (not yours), disseminate tasks rather than relying on calcified job descriptions. Create a human flow chart that leads to mission execution. If you simply try to replace boxes on an organizational chart—one that might have been developed externally (either by a corporate board member, a consultant, or a predecessor)— you'll just continue to hire for the job instead of for the person. You'll miss out on terrific hires and employees, and because you are not asking them to do their best work, the current staff members will keep quitting.
- Be *their assistant*, especially in small organizations, rather than insisting on having them be yours. When they do well, you'll do well. As a leader, if you can't shine the light of the power of the nonprofit by inspiring those who report to you, then you don't really know what "team" means. See every team member of your organization every day, even if it's just to wish them a good morning. Rather than asking them to help you, find ways of asking to help

them. To reiterate, it doesn't matter who gets the credit as long as the good change happens in the community.

- Don't let "results" become your mood ring. Use "happiness" instead. Or "satisfaction." The goal of a good nonprofit arts organization is not a one-time win, like a baseball game. It's a long-term effort, like a child's education. Each accomplishment leads to another; then another; then another. Also, results can often be arbitrarily set before conditions set in. Did your development staff "fail" when the pandemic came along, bursting any illusion that an annual budget goal would be met?

The "H" in "HR," the End of Group Interviews, and Decision-Making

I asked a colleague of mine who ran a Chicagoland theater company about her views on hiring. She told me that she didn't have time to go through each résumé and respond. She made the process entirely inward-facing; she just wanted hiring to be convenient for her, not for the people looking for a chance to join her organization.

I think it's important to look at those who send in a résumé as…what's the phrase again?

Oh yes. *Human beings.*

Candidates are human beings who are testing you just as much as you are testing them.

In fact, taken a step further, when the candidate is asked to sit in front of the entire department for a group interview/focus group—or to be present for more than three interviews with different people at each interview—it can be worse.

Making decisions by focus group is a horrible idea. Certainly Henry Ford thought so (him again?): "If I had asked people what they wanted, they would have said faster horses."

Making hiring decisions by group interviews is a terrible idea. Meet-and-greets are fine, but not full-on interrogations. To

everyone I've ever put through that, on either side of the table, I apologize. I'll never do it again. Promise.

The group interview is, in my opinion, based on doing hundreds of them, wholly soulless. It provides almost no room for exceptional candidates who are not clones of the current staff. In most, each person uncomfortably takes turns reading pre-designed, pre-printed questions in the dullest drones imaginable. Your staff turns into a cast of zombies in a badly written, badly acted play, and everyone uses the same dull inflection to every candidate.

There are four kinds of decisions: *autocratic* (I say), *consultative* (I say with your input), *democratic* (we vote, losers weep), and *consensus* (we vote and everyone backs the decision).

Consensus decision-making is the ideal for every strategic decision in your company. But, as we all know, ideals are hard to put into practice. Consensus is not unanimity, except in terms of backing the final decision. It isn't necessarily fair, because fairness is irrelevant when you're seeking great people. Group-think promises consensus but often devolves into "democratic" decision-making and can preclude innovation with hurt feelings.

In hiring, oftentimes a *consultative* decision-making process might work as well, as long as there are clear processes and communication lines open to every member of the team. Remember one caveat, however: if you want your staff to be included in the process, that's terrific, as long as everyone knows that their joy for—or disgust for—any candidate will not lead to a final hiring decision. One person is responsible for the hire (you), but taking in data is never a bad idea. And if there are strong feelings for or against, you'll want to know them, investigate them, and weigh the pros and cons.

After the decision, it is up to your staff to promote consensus around that decision, *regardless of whether they agree with it*. If that can't happen, we're back in high school where the popular

cliques choose the agenda. Hiring can be a consultative process, but it cannot devolve to a group-think process.

The group-think process can too often be dominated by a need to find someone who feels, sounds, thinks, and, too often, *looks* like they do. And almost always, if even one person speaks up against a certain candidate, the rest of the team will fall in line behind that because they do not want to cause trouble — even if that candidate is the best one for the company.

You Can't Win the Fight—You Can, However, Win the Round

Each issue that stands in the way of your community's success is like a round of boxing. Each time you win a round, you and your organization will be deemed indispensable. But, like an old John L. Sullivan fight in the 1920s, there is no round limitation. In fact, the same round might be fought again and again. Your nonprofit is in the business of winning rounds, not winning championships, using the limited tools that are allotted to you.

Making art is hard. Demanding. Excruciating. The high is galactic when it speaks to you. Lower than dirt when mediocre. In fact, it could be said that mediocre art is worse than spirited bad art.

Making a nonprofit arts organization work well is hard. The very notion of creating art as a tool to tangibly improve the community in which you live is daunting. So daunting, in fact, that most do not attempt it; they merely use the 501(c)(3) status as a way to increase revenues because ticket sales cannot. Then, when a crisis not of their own making arises (a global pandemic, a hurricane, a recession, a riot) and ceases ticket sales, they no longer have worth, leaving them to go out there and ask for money because they can't make money. Chutzpah, perhaps, but not the good kind of chutzpah.

But for those few who take their charter to heart, the fight goes on. The boxing match never ends. In fact, it never even

feels as though the match had a beginning. There's a round. And the next. And the next.

- Round 1. Do the work. Whatever that means to you.
- Round 2. Get the money to do the work.
- Round 3. Report the impact of the work to get additional money to do the work.
- Round 4. Contract the artists so they can help your impact to get additional money to do the work.
- Round 5. Contract the staff so they can report the activities of the artists that help your impact to get additional money to do the work.
- Round 6. Engage the board to zealously spread the information gleaned by the staff reporting the activities of the artists that help your impact to get additional money to do the work.
- Round 7. Do the work. More work. More impactful work. Better, more impactful work.
- Round 8. Round 9. Round 10. Round 11...Round 150... Round 437...Round 8,192...

There is no end to the match, so there is no single moment of victory where your glove is raised by a referee. Even when you retire, the match continues. Other people will use other tactics to box their opponents.

The work done in a nonprofit arts organization alternately energizes and enervates—not based on success vs. failure, but rather, real belief (doing activities for the advancement of a cause) vs. pantomime belief (doing activities for *what looks a lot like, but isn't* the advancement of a cause). When one really believes in the impact, temporary disappointment and gloom fail to eliminate the joyful energy of accomplishment.

For example, if your intent was to raise funds to feed, clothe, and house 30 homeless men and women in a "temporary tiny

house" neighborhood and you only raise enough for 20, you may be frustrated that you couldn't do more, but you revel in the success of the 20. You keep working at it with joyful energy and a feeling of accomplishment, and work on next steps for that 20.

But if your intent was to entertain those same homeless men and women, but not attempt to find food, clothing, or housing for them, you might well feel a sense of success. In actuality, however, those homeless people will be no better off in what they actually *needed*.

Real belief is how failure can ultimately motivate success.

So, how does one gain real belief?

There goes the bell for the next round. Go get 'em.

Find Funding for Why You Do What You Do, Not Where You Do It

If you own a building, sell it.

If you want a building, rent it.

If you want a home, call a realtor. There are plenty on the market.

Don't own your own performance space. It's a liability, not an asset. Balance sheet be damned.

On the books, owned buildings show up as an asset. Millions of dollars of retained earnings on the balance sheet. Your organization looks prosperous, right?

But an asset, in its truest sense, is something you can sell. No one wants to buy a theater or concert hall...unless it's to tear it down and build condos. The worst circumstance is when you own a Historic Building. If you do, and you cannot make the necessary changes to it in order to make the community better off (because of laws against renovation), you might be screwed.

This isn't just about avoiding an "Edifice Complex," a condition that compels some members of a board, staff, or

donor pool to leave a tangible personal legacy, a memento they can point to with affection and say, "I did that."

Space is important. It's costly and vital. You just don't have to own it. In fact, one of the most overlooked ways in which a board member can help an organization is to provide eternal, free nearby office space for the company. It's a major tax deduction and the perfect in-kind gift—one that actually removes a necessary expense from the budget.

Think of the value a building brings your company this way:

- If everyone around you has scurvy and you have a crate of oranges, you have a valuable commodity.
- If everyone around you has a truck full of free oranges and you have a crate of oranges, you have a mostly worthless commodity.
- And if you live in a world where oranges don't solve a problem but apples do, your oranges might be considered superfluous. While they might taste good, they are not necessary in your world.

I don't know. Maybe the analogy and metaphor police will give me a ticket for that one.

Or that one.

An Example of the Advantages of Flexibility and Freedom (and No Building)

Many nonprofits in the arts have chosen to engage in massive fundraising efforts to build buildings. But buildings in and of themselves are not your duty.

A capital campaign for a new facility is like raising money for launch pads. NASA's mission is to "pioneer the future in space exploration, scientific discovery and aeronautics research." Not "build the best launch pad."

The building may last, but the company may die from spent energy, mission drift, and rationalizing programming for the new space.

Have you even tried utilizing other venues? Or better, utilizing a mobile venue?

The Long Wharf Theatre, as much a standard-bearer of the American theater scene as any nonprofit across the country, has made that welcome decision. As of 2023, they are completely itinerant after a 57-year history in Connecticut, in a venue located in the New Haven Food Terminal. A friend of mine who used to work there described the entry to the theater as "walking in high heels through meat." I don't know if she was being literal when she said that, but that's a possibility.

As Michael Paulsen of the *New York Times* wrote in February 2022, when the company announced this radical change:

> The leadership of the nonprofit theater is framing the move as an opportunity to reach new audiences and reimagine its operations, and the city is supporting the change, which it says will help the organization better serve the community...
> The theater, which has been among the nation's leading regional nonprofits, also faces the same challenges as its peers: demonstrating to patrons, artists, and donors that it can move forward following the lengthy pandemic shutdown, and that it is committed to shifting priorities in response to industrywide calls for more diversity, equity, and inclusion.

The city of New Haven is firmly behind the decision, even though the Long Wharf has, for years, been a tourist destination for the region. The city's priorities have changed, including a strong cultural equity plan, which served as one of many catalysts for the move.

"Long Wharf's idea of being more mobile, moving throughout the city and coming to communities who are not making it down

to where Long Wharf is now, is very responsive to our plan," said Adriane Jefferson, the city's director of cultural affairs. "I would have concerns if they weren't thinking along these lines."

One of the wonderful things about art—especially performing art—is that impact can happen anywhere. Having a home venue may seem like a sanctuary, of sorts, but can you reach the people who need you?

There are startups in the world creating "push-button houses," completely manufactured homes that can be folded into themselves to the size of a standard truck shipping container. If you took this technology and applied it to performing spaces, you could have your own venue placed anywhere you want, even for one day, just an hour after pressing a button.

Imagine. A theater, backstage, flyspace, wings, seats, and even a canopy over the seats. All and more at the press of a button.

The technology exists. The product exists. There is a bigger need for the impact you offer outside your current building than inside it. Just like that launching pad at Cape Canaveral, your building offers only temporary shelter for something far more impactful, the rocket.

Sell your building, if you can. Get out from under all those expenses that you've discovered are killing you.

Use other spaces. All kinds of other spaces. Picnic tables at a local park, if the weather works. If it doesn't, that's trickier, but there are empty stores everywhere that can quickly be configured into a performance space. (Note: it won't be gorgeous, but if your mission is to produce art to accomplish a goal, the space won't matter.)

If you can't sell your space, rip everything out in the audience's area to the bare floors and walls. Then find ways to produce something that means something now without reverting to the It's Still Relevant Today™ campaign.

Remember your mission is not to produce art, it is to produce impact. What impacts does your *whole* community need right now? Is your building holding you back?

Tickets Are a Tool of Equality, Not Equity...So Stop Selling Them

Give your tickets away.

Give *all* your tickets away.

Give them to people you choose instead of those who happen to choose you.

If you believe that the art you produce has the ability to make people healthier, more engaged in the community, and more curious about what they can do to create the environment they want, then it follows that your art has more than meaning, it potentially has catalyzing properties.

If you can point out the actions that were taken by those experiencing your art, quantifying them (the number of people who used your art to lift themselves out of homelessness, for example), then your company is worth supporting. And if more underserved people can be catalyzed by offering free tickets— to them and only them—then the community becomes a better place to live.

Giving your tickets to people that wouldn't be able to see their lives contextualized on a stage is a no-brainer.

It's not as radical an idea as it may seem on the surface. Mixed Blood Theatre does it.

But it does put pressure on the artistic team in your company to produce works that offer the kind of experience designed to do all those things, not just to produce the latest Broadway or Off-Broadway hit or a stream of Eurocentric (white) symphonies meant to appeal to the privileged few.

It also puts some pressure on your development department. All of the revenue—all of it—would be coming from a donor pool. It's important to remember, of course, that *just about every*

other nonprofit organization works this way, with only one revenue stream. It should be nothing new to a seasoned development officer capable of looking at the work through the prism of helping people who need it, rather than entertaining donors who don't.

Determine your success by how many underserved, overlooked, and disadvantaged people you served, not how "good" the art was. It'll put critics out of business, I suppose, but there are fewer art critics than there have ever been. Arts journalism—because the arts themselves have found themselves as activities of the elite—has decreased to a mere trickle. If an editor were to see and hear how communities were made better via the work of an arts organization, there might be better coverage.

In any case, stop worrying about how to diversify your ticket-buyers. Diversify them yourself. Choose the people you want to serve from that pool of those who cannot afford it.

Then, because your audiences are always full, because you have filled the houses with people who need your services... Because you've chosen impact over income, you will have no need for subscriptions, single ticket sales, acclaim, and every other item that you currently may believe provides a *raison d'être.*

Instead, convert your siloed marketing and development departments into a single department. Combine the key resources of press, marketing, and development into a cohesive message of intent, action, and impact. Keep the company's feet to the fire by showing how much can be raised by doing work for underserved people (instead of doing work for a donor). Spread the word about the good work your company does. And, most importantly, why.

The hardest issue will be converting the thought processes of many people...perhaps even yours. The best way is to have one-on-one meetings with everyone involved. Bring in key

stakeholders, one by one, who are not a part of your company (city cultural affairs officers, using the example of the Long Wharf). Then small groups. Then, when you seem to have a consensus, jump on it with larger groups. It will take a lot of effort and time, but the community—a community that is battered, bruised, and much more diverse than you ever thought it was—may finally thank you.

If you don't want to do any of this—if your goal is to get glory, awards, or some ill-advised notion of "art for art's sake" that serves only the artist—*there is no shame in opening a commercial business* where ticket sales come first. Instead of donors to fill in the gaps, get investors and pay them back when the show is a hit. If it's not, they won't expect a return.

Watch the 1967 Mel Brooks movie, *The Producers*, starring Zero Mostel and Gene Wilder. Think of it as a documentary.

And a special note to leaders of foundations that fund nonprofit arts organizations: please require your grantees (all of them) to show their *measurable* contributions to society and how they help the underserved in the community. Do not accept "butts in seats" as a metric unless the seats were offered free to the underserved communities the arts organization has promised to serve. Ask for metrics that show how much better the members of the community are. When you don't, and just give them money because they might serve as a community resource, you're essentially practicing trickle-down philanthropy, and we all know how ineffective trickle-down theory is. Your gifts, because they are earned with constant attention to making the community a better place to live, show the best kind of support.

Active Solidarity

Do you remember the movie *Miracle on 34th Street*? I'm referencing the original, of course, with Edmund Gwenn, Maureen O'Hara, John Payne, and little Natalie Wood. In it, among other plot details, a Macy's Santa Claus starts referring

customers to Gimbel's, Macy's rival store across the street, for certain items. While it initially causes Macy's to fire the Santa Claus, sales skyrocket in the toy department because customers begin to immediately trust Macy's selfless acts of the Christmas spirit.

You can do this, too. I call it "Active Solidarity." Here's how it works.

Let's say that after doing all the research you could, you find that a particular donor to whom you've been sending information is not really interested in supporting your company's work. Rather than ghost that potential donor, why not behave as a friend or advisor would?

If your friend (no longer "potential donor") prefers to support causes that eliminate animal cruelty, look through your contacts for someone that runs a rescue service. Or maybe someone you know is a leader at a local anti-vivisection charity. If you don't have someone in your own contacts list, just look up organizations yourself—maybe concentrating on small, local ones—and call up their executive director. Tell that executive director the truth. You've been wooing a donor and find that they are more interested in animal rights than the arts. Introduce the friend to that executive director, either by email, Zoom, or a couple of phone calls.

Now you have two friends.

When you explain Active Solidarity to your new executive director friend at the animal rescue, there is every chance that they know someone who likes to support the arts. Or that they have another executive director friend who knows someone. Suddenly, you have a group of Active Solidarity leaders funding each other.

It won't be fair, of course. Some groups may benefit more than others. That's okay. You're running a nonprofit organization for the greater good of the community, not to make more development revenues than the next guy, right?

It's also a great way to include under-represented nonprofits that have not historically been able to obtain donated revenues from the usual arts donors (white folks) in your circle. As Jeff Wokulira Ssebaggala and Annie Lascoe point out in *Philanthropy News Digest*:

> Typically, funders look to other funders for introductions to grantees, creating an exclusionary precedent within the fundraising world that exacerbates existing power disparities. The fundraising sector has a long-documented history of allowing unconscious and conscious bias to skew funding decisions toward white-led NGOs. This legacy, compounded by the fact that many civil society groups and activists do not have the capacity or time needed to make introductions to funders, further bars frontline communities from accessing critical resources. The discriminatory practices embedded within the current model, and the industry's failure to address them, also discourage Black, Indigenous, and people of color (BIPOC) fundraisers from accessing necessary funds.

Isn't the betterment of the *entire community* the central purpose for the nonprofit sector? You can help that happen with Active Solidarity.

Allow your whole community of nonprofit arts organizations to thrive. Give disgruntled customers the box office numbers for the local theaters, symphonies, dance companies, and museums in the region that produce work they want to see. Share what you've heard about these events and happily recommend a wonderful experience. Contact all those organizations ahead of time to let them know you'll be doing that, and perhaps, in the name of solidarity, if a patron were to call them about the kind of work you tend to do, have them recommend your organization.

Active Solidarity is not a data-driven decision. It's a Santa Claus decision. It's always the right thing to do to help other nonprofits achieve their goals, too.

Be the Expert

Active Solidarity outside the arts realm might make your organization a trusted clearinghouse of community information. That's a good thing. To be considered the "expert at what you do," you have to know the other things going on around you. Tunnel-vision is not a good strategy for doing that.

I usually describe "expert at what you do" in terms of being that person or organization that receives a call from the local NPR newsroom when something happens that affects your corner of the industry. If, for example, a performance venue becomes permanently shuttered, that newsroom will contact (at some point) the expert on the arts in your region. That should be someone from your organization; usually your executive director.

As a participant in Active Solidarity, a nonprofit arts organization led by a strong executive director might choose to drop everything and help during a crisis.

That's what the community wants you to do.

Several arts and arts education organizations across North America took it upon themselves to take on the scourge of COVID. Among others, the Vancouver Opera, Arts Club (Vancouver), Opera San Jose, Houston Grand Opera, TheatreWorks (Silicon Valley), Milwaukee Ballet, and the Shaw Festival (Ontario) revved up their costume shops to create, sew, and distribute thousands of needed masks and gowns all over their respective communities.

In 2005, just a year after the historic and tourist-attracting Seattle Monorail caught fire, eight doors on one train and one on its other train crumpled when the two trains sideswiped in a

crunching, dangerous accident on a curve. Rather than getting nine replacement doors from the manufacturer—located in Austria, with a massive backlog—Seattle Opera's Scenic Studios built the new doors, at a cost of $15,000 each, to help the train reopen by Labor Day 2006.

"We're used to building for safety," Seattle Opera spokeswoman Rosemary Jones said at the time. "Most of the things we build, people have to stand on them and sing. We don't want them plunging."

Look for opportunities like this; don't just wait for them to happen. When you make it a point to create impact instead of just presenting artistic events—even if the impact helps another nonprofit and not you—you're making yourselves indispensable. And rather than waiting for a disaster (hurricane, flood, train wreck, pernicious global pandemic), take the reins and, using Active Solidarity, choose to help.

Who knows? The next time you need help, maybe a non-arts nonprofit might help you.

Exercises: Change and Perspective

Before we start talking about the future and the next cycle that will likely determine the evolution of the experiment known as "nonprofit arts organizations," get a group of stakeholders together and examine these two exercises. The first is about change; the second is about perspective.

Exercise 1. Change
Examine the two sets of photos on the next page, set A and set B. The first photo in set A is different from the second photo in set A. It's the same for set B.

Can you spot the differences between the first photo and the second within each set?

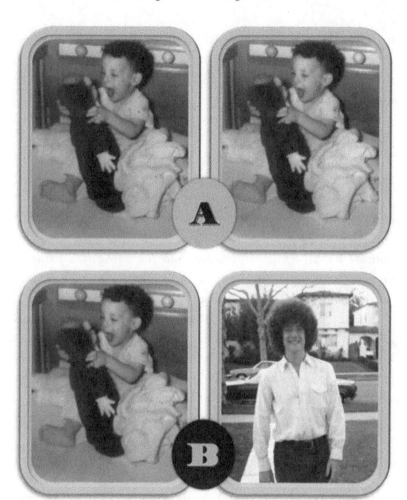

Incremental change is characterized by set A. The contrast setting and the brightness setting have been changed from 50 to 52. It's hardly noticeable. Ultimately, no one will react any differently.

Fundamental change is characterized by set B. It's noticeable. People will react differently.

Change and risk sound laudable and dissonant. They *are* laudable and dissonant.

Real risk based on real change might cause dizzying financial loss (in the short run) for the average arts organization. When conscience dictates that you have to do the right thing, as defined by diverting, equitizing, and including (DEI) under-represented communities in your set of stakeholders, you have no choice but to risk and change.

Board chairs, executive directors, artistic directors, and development directors of nonprofit arts organizations are not known for their entries in the latest "Profiles in Courage." They can easily be swayed to inaction by the thought of lost revenues, even when the change is the right thing to do.

So, referencing set A, should your change be so incremental as not to be noticed?

In a word…

No.

Incremental change tantalizingly offers an easy opportunity to kick the DEI can down the road. Fundamental change requires your organization to *fundamentally change.*

You're already taking the risks necessary to be a part of a just society by implementing a rigid DEI policy, right? Your bottom-line financials are at risk, not to mention your reputation as an arts organization (whatever you believe it is, anyway).

It would be foolish to believe that DEI programs are unnecessary. The risk is greater that social justice groups will not believe you have any intention of changing for the better. If they see only subtle changes, let alone none at all, why wouldn't

they believe that your company is stalling, hedging its bets, and just waiting for this movement to blow over?

Any trust in your organization's ability to achieve impact goes out the window when that happens. Enacting a proper DEI protocol is a key way to positively impact your community.

Obviously, you can't diversify your stakeholders without alienating many of your toxic patrons. DEI programs are nearly guaranteed to alienate the racists among that group. Remember the bathtub? You won't alienate *all* of your stakeholders, *unless all of your stakeholders are toxic.*

Don't rationalize toadying to those patrons who resent your DEI programs. That's like treating cancer by merely asking it not to kill you because you're afraid that the tumor might have hurt feelings if you surgically remove it from your body.

The purpose of a nonprofit is to help solve a societal problem, not kowtow to donors. Donor-centric fundraising never was intended to let the donors solve the problem; it was intended to inform the donors how well you are attacking that issue. Toxic extortion is only good for your bottom line, not the company's. Your job will change quite a bit as these changes take place, just like everyone else's. Because it's not about you.

Like someone on a scorching day thinking about diving into a pool without knowing its temperature, the time between standing on the pool's edge and the initial shock of cool water can cause great anxiety. But within seconds of immersion, the body adjusts and the temporary briskness of the water makes way to a feeling of welcome refreshment. Adrenaline flows and endorphins are released.

Fundamental change works the same way.

Exercise 2. Perspective
This exercise takes far less time to execute and the results will be apparent in moments. It's important that you do the change

exercise first, however, because without it, the perspective exercise might seem meaningless to you and your stakeholders.

Raise your right hand into the air, at reasonably full arm extension. Don't strain. It's not about the arm.

Point your right index finger up and put the rest of the hands into a fist, as though you were announcing to the world that "We're number 1."

Now waggle that finger in a clockwise circle. In the 1960s and 1970s, this would have been a symbol for a sarcastic "whoop-de-doo." Regardless, continue to have your finger move in that clockwise circle throughout the rest of the exercise. Make sure it's going clockwise.

Slowly lower your right hand below your head. Now look at the direction in which your finger is waggling. If you've done it correctly, it is now moving in a counterclockwise motion.

What you've learned is this: the actions you take to improve your community will absolutely be viewed in different ways, whether you like it or not. In fact, your actions might be viewed as achieving the *opposite of your intention*, depending on the perspective of the beholder of those actions.

The "nonprofit" in a nonprofit arts organization is ultimately way more important than the "arts." Take the trust you've been given and use that art to make a better community.

That alone will allow you to look at the future as something bright, not the same-ol'-same-ol'.

Chapter 10

The Future—Nonprofits, Arts Organizations, and Saving Humankind

In order to get the future you want, paint a picture of what success looks like. Be detailed in the picture. Otherwise, you'll just get the future you get. As comedienne "Moms" Mabley used to say at the end of her act, "If you always do what you've always done, then you'll always get what you always got."

It Is 2047

Here we are, 27 years after the first US COVID-19 case in Kirkland, Washington. Thank goodness that after the Psi 2.3.2.3.5.2.6.1.137 variant of 2035, the combined leadership of Canaméxico's Prime Minister Alexandria Ocasio-Cortez and Pacifica's President Greta Thunberg overcame the stubborn incompetence of New Auschwitz President-for-Life Eric Trump and his citizenry. Getting President-for-Life Trump to approve the construction of a virus-blocking dome surrounding his nascent nation was one genius action. Getting him to pay for it was quite the coup. So to speak.

It took nine score years since Lincoln's Gettysburg Address to determine that the most effective route to a stable house involved removing the dividing offender rather than forcing the egregious to capitulate for the sake of comity. Hence today's decidedly more effective map (see next page).

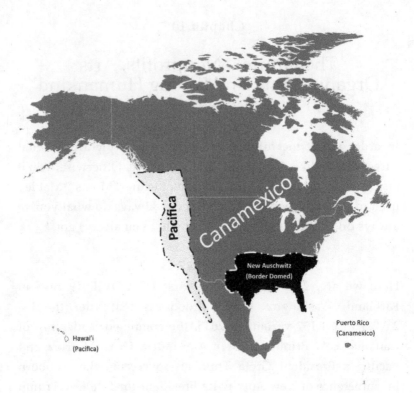

Here in the sister nations of Canaméxico and Pacifica, where the viral and political machinations have already passed, nonprofit arts organizations have succeeded in using their unusually effective artistic tools to lift the fortunes of their communities. The underserved are being served as they never have been. More underserved people have been fed, clothed, and housed using the work of arts organizations than ever before.

How did we get here?

Back in the early 2020s, the most unenlightened arts companies tried to "reopen" rather than inventing themselves anew. They tried to promote a decades-old formula by which rich people donated to nonprofit arts organizations in order to

keep them open. In that method, the same rich donors attended those same nonprofit arts organizations. Needless to say, that led to a graying, insubstantial audience. Eventually, they would have died off on their own. That, in turn, would have ultimately closed these nonprofits down.

All the virus did was speed things along. These same older people were the most susceptible to dying of the virus. After the first set of vaccines, they were still loath to go out. And thus, those unenlightened companies closed down.

"It's sad," said one former artistic director (a title and leadership position that has since gone out of vogue), who only agreed to speak on condition of anonymity. "We wanted to leave a legacy. We wanted people to point to our building and say, 'Something wonderful happened there.' Even while we were going bankrupt, we thought people would want to be a part of that legacy."

"What we didn't count on," they continued, "was that most of the community really didn't care about us. And they certainly didn't care about the building. They looked at us as a pleasant money-sucker, even in the best of times, because we didn't do anything for them except produce art. Art is necessary for enlightenment—I think everyone agrees on that—but we completely overstated the case that our version of art was necessary for anything."

"We should have known better," they concluded, "but we were arrogant and ignorant, and that's a fatal combination."

Let's look at a couple of the successful nonprofit arts organizations on the North American continent.

In Pacifica's capital city of Seattle, 501 Repertory Company is entering its twentieth year of producing plays. Its mission is to "strengthen Seattle's most impactful charities in an effort to level the playing field for the most vulnerable among us." Decades ago, an arts organization that excluded its art of choice

in its mission statement would have been considered radically non-artistic. Isn't it wonderful that we have collectively moved beyond that ridiculous maxim?

The efforts of 501 Rep have succeeded beyond anyone's expectations in large part because the plays it produces are meant to effect change, not merely to inspire it. Its activities include play production, educational competition, and advocacy. Each piece is new and is chosen for its value to a chosen 501 Rep partner nonprofit. For example, a nonprofit involved with voting rights would be paired with a play advocating for expanded voting rights—not as polemic, but in a way that is both entertaining and effective.

The company accepts no earned revenue at all, depending instead on two funds from which to pay its expenses. The Nonprofit Fund garners revenue meant to be split 50/50 with the nonprofit partners of the organization. The Arts Action Fund provides operational expenses so that the company can continue to aid in its goal of lifting worthy nonprofits across the area.

While it is financially thriving and has helped other nonprofits pass legislation, reduce poverty, end homelessness, and more, the money is not the goal of 501 Rep. Its impresario, John Q. Public, told us that the center of its description of success is this:

501 Rep has firmly established itself as an indispensable activist nonprofit. Our goals are externally faced. We were founded on the notion that universal appeal is impossible. The musician and songwriter Harry Nilsson once said, "A point in every direction is the same as no point at all." When underserved people succeed—people who never thought they would ever benefit from a company that produces plays, of all things—501 Rep has won another battle because the community is better off.

Based in the central Canaméxican hub of Minneapolis, the breakup of the former Children's Theatre Company has borne three remarkable children-targeted nonprofit arts organizations. Working together, and working with strict parameters, rubrics, and measurable results, the three companies serve as a nationwide artistic assembly line of sorts, with the intention of teaching children personal life-skills that will benefit them for the rest of their lives.

The Primary Theatre Experience (PTE), with a mission statement "to imbue children aged 5–8 with the confidence to be curious, expressive, and collaborative," uses substitution and improvisation to help children disregard the self-defeating limits of attaining a prescribed potential.

PTE productions involve both the teacher-actors and the students themselves. The plays follow a highly acclaimed scientific process based on research determining the relationship between self-esteem, achievement goals, and academic achievement among the primary school students as being paramount to ascertaining student success.

The executive director of the organization, Jane W. Doe, took it a step further: "Thanks to one particular sponsor, we issue two sets of identical pants and shoes to each student. We also issue three shirts in the same style and fabric of shirt, which the students can choose from among ten available colors. In this minor way, our aim is to reduce socio-economic differences among the students, giving them a level playing-field on which to achieve."

The care taken to utilize positive reinforcement for good behaviors converts to a higher academic floor for each child, especially for those with developmental disabilities or basic needs insecurities, and for those who do not speak English. Their idea is to use Maslow's Hierarchy of Needs as a guide and carefully move up that pyramid at least two levels (physiological;

safety). The results have been staggering, as every child is skill-tested upon entry and right before graduation. The average increase in achievement has opened the eyes of government on attaining these crucial skills in a way that could ONLY be attained in an arts organization.

The Middle Grade Theatre Experience (MGTE), for ages 8–13, expands on the success of PTE by adding early playwriting and directing skills to the performers. They, too, use Maslow as a guide, reaffirming the students' needs and adding the third and fourth levels of the pyramid (love and belonging; esteem). Due to their amazing results in raising the playing field, both PTE and MGTE have spread and now each exists in over 800 communities across Canaméxico and in neighboring Pacifica, serving over 5 million students every day.

The third group, the Youth Expression Success Experience (YES), takes former PTE and MGTE students and safely instills the highest level of Maslow's Hierarchy of Needs, self-actualization. In addition to the reliable state funding, YES utilizes a special sponsorship fund, The YES We Can Fund, to hold annual performance festivals. YES provides scholarship money given directly to winning students' college funds in a competition devoid of sets, costumes, makeup, and anything else that might get in the way of a level playing-field for those students who have passion, drive, and intelligence, but no money to buy such trappings.

"We've seen the reports," said PM Ocasio-Cortez, "we've read the research, and we now see that because these three companies target skill growth for youth as their primary activity, students who have taken part have grown into today's leaders. It is why the nation fully funds these programs each year, with no dissent from any of the political parties. It's not as though they're just putting on plays for kids. They're growing them into fantastic leaders, no matter what their home situation is."

None of these arts programs would have been possible but for the early 2020s pandemic. The United States was too fragmented and cowing to special interests until then. The country's citizenry was too busy yelling about what's "good for my children" to notice that the system was failing almost everyone's children. The freedom that came from those who treated what everyone used to call "the new normal" as an opportunity to invent (rather than as an opportunity to reopen) provided this amazing increase in achievement for everyone.

Using the arts as a tool to achieve an end has proven to be much more exciting than using the arts as an end, in and of itself.

Changing Times Require Changing Perspectives and Changing Predictions

We're in the middle of something transformational. We just don't know exactly what it is. But whatever it is, it will somehow be familiar to those who study such things.

It's okay to be confused. Just go with it.

As David Brooks wrote in the *New York Times*:

Sometimes in life you should stick to your worldview and defend it against criticism. But sometimes the world is genuinely different than it was before. At those moments the crucial skills are the ones nobody teaches you: how to reorganize your mind, how to see with new eyes.

The future used to be something bright and exciting, described in H. G. Wells' *Men Like Gods* in 1923. Wells' utopian society probably looked like *The Jetsons*.

After that, the future was dysfunctional, autocratic, and often, absurd, much like Franz Kafka's *The Metamorphosis*. The absurdity of a man slowly turning into a cockroach. How bizarre. How nonconformist. It probably looked like *Dr. Strangelove*.

After that, the future became a combination moral/physical journey. Jason and the Argonauts from the third century BCE... which looks a lot like *Star Trek.*

The Future Will Not Be the Past, but Something Like It Has Happened Before

While the specific future, both for your community and your nonprofit arts organization, has not happened yet, there is ample evidence that something very much like it has. That's what history is for—to contextualize the issues of the day by seeing how something similar may have been treated.

There are two kinds of people when it comes to history. Many eschew its lessons. The rest take advantage of people who eschew its lessons. If you believe that there is a better future for your community, and that your nonprofit arts organization can catalyze the change necessary for that future, your responsibility is to do everything you can to make that happen. That will raise the factor of indispensability to its highest level, keying your company's sustainability, reputation as a community player, and, more importantly, its ability to lift lives.

Your nonprofit arts organization would be at the center of the transformation. The destruction of norms—a prerequisite for any major transformation—has not only begun, but has itself become the current norm. An itchy and badly irritated skin-shedding, as it were, toward a newly exposed, nerves-at-the-surface "next normal" is in process, whether you acknowledge it or not.

Like the experience of riding a bucking bronco, your leadership task may be to ride it out, to jump off in fear, or to be trampled. But it's all happened before.

We are in the midst of a momentous catastrophe of world history, of a transformation of all aspects of life and of the entire inner human being. This is perhaps fortunate

for the artistic person, if he is strong enough to bear the consequences, because what we need is the courage to have inner experience.

—Walter Gropius, 1919

Yup. 1919. That's not a typo. Gropius' reference is to the misnamed Spanish Flu (which started in the United States).

What happens when cataclysmic change occurs in the nonprofit sector?

As always, there will be nonprofit leaders who put their blinders on and focus on the mechanisms and minutiae. Process, process, process.

It is their nature to do so, and in times of great strain, that is the go-to for individuals desperate to wrap their arms around the two tracks of doing nonprofit service and dealing with exhausting change. They use standards, detail, and tactics in lieu of connecting, relating, and dealing with big ideas. They'll put together a strategic plan with spreadsheet after bloodshot spreadsheet backed by heavy analysis. That detailed analysis, however, is likely to have been built with the leaders' goals in mind. Rather than allowing their data to lead to a conclusion, these leaders will force their conclusion to lead to data.

Others will lift their heads straight up and take part in the change, not without apprehension or panic, but certainly with wonder about what happens next. They may stay at the 50,000-foot level in analyzing the next steps the organization ought to take, using the most recent ideas someone used with success, somewhere, sometime recently. The latest idea might solve problems, especially those from the more influential "corporate" world.

Still others will pooh-pooh the fact that any change is happening and look to rebuild a dying nonprofit paradigm that is as effective as increasing the octane to 93 for an electric car. They'll be stuck using the same tactics that worked in a year that

began with "19" and blaming subordinates who simply "do not understand what's important."

In the nonprofit arts, the obscenity of donors donating so that donors can attend must end. Not merely from a moral standpoint, but from a generational one. New donors simply do not want what the last donors wanted.

There has been a lot of gobbledygook for the last several years about generational wealth transfer. Big, loud graphic representations.

There's this weird thing, though. Firstly, wealth transferring from one generation directly to an arts organization is great for that organization, but not for the field. Those receiving the cash will crow about how "a rising tide lifts all boats."

Truth is, a rising tide sinks a whole bunch of boats, destroys a town's infrastructure, and drowns a hell of a lot of people.

Secondly, wealth transferring from that same generation to their heirs has a funny way of ending up funding the intent of those heirs and not the intent of the original (now dead) donor.

Sadly, the dying generation may be the last that views donating to nonprofits as part of their civic rent. If the next billionaire class is any example, they're likelier to send themselves into space, polluting the upper atmospheres.

Ultimately, the kinds of nonprofit giving that have gone to the arts—especially to the largest arts organizations—are in line to evaporate over the next 15 years in favor of whatever suits the next generation. It might be rocket ships. It might be something no one has thought of yet. Taste and passion are much more ephemeral than you suspect.

What happened in history the last time there was such a monumental shift in life as we know it? Does that inform your next decision? Do you (and your organization) evolve by using extensive research, data, and community connection?

Or do you just damn the torpedoes? (Caution: if you just keep damning torpedoes, you'll probably get hit by one. At least one.)

One thing is for sure, as big transformations change society (from 9/11 to Afghanistan to derivatives to subprime mortgages to religious fundamentalism to vapid celebrity to the loss of irony to championing narcissistic idiots to a global pandemic to…?), the next version has likely already happened. Your task is to deal with it, however you can, for the betterment of humankind. Start by acknowledging that the immediate past is less relevant than the spirit of the past of 90 years ago. Then adapt.

The Future, in Fact, Can Be Made Better…by Art

The idea of using conversion art (see Chapter 7) to create a blueprint of a better society has happened before in America. The author, an unlikely nineteenth-century French stockbroker, was Jules Verne.

From the time of The Compromise of 1850—a series of acts and laws that ultimately fomented the Civil War—to the ratification of the Fifteenth Amendment—the constitutional act created to fully establish the right to vote of any citizen (note: except for women) based on "race, color, or previous condition of servitude"—the United States suffered its first existential crisis not based on the desires of England. So many tipping points occurred in such a condensed timeframe that the future of the country, its citizens, its economy, and the moral and literal destruction of Black people could have caused a cellular, national destruction at any moment during that time.

Among other things that happened during that era, Jules Verne entered his "positivist period."

For more than two decades he churned out many successful science-adventure novels, including *Journey to the Center of the Earth, From the Earth to the Moon, Around the Moon, Twenty Thousand Leagues Under the Sea,* and *Around the World in Eighty Days.* All these novels were not only exciting page-turners, but also visions of a future that promised adventure, excitement,

and a better world. In Verne's world(s), there was no room for dystopia.

American readers, especially those with the power to influence (e.g., white, wealthy progressives), were enthralled with this new genre of literature. Those with imaginations looked at these stories as starting points, catalyzing them into a kind of story fulfillment that continues to this day at companies such as JPL, NASA, and Boeing. Verne became the second-most translated author in the world (behind William Shakespeare and ahead of Agatha Christie).

The arts can provide a road map out of the destructionist period in which we see ourselves. Your arts organization, or a collective of like-minded arts organizations, might be able to use forward-thinking information to further your cause instead of habitually looking at, say, the last ten years.

Forward thinking will get you out of the grind of survival strategies.

As financial advisors often write, "Past performance is no guarantee of future results." And as nonprofit expert Seth Godin once wrote, "Survival is not the goal, transformative success is."

The best way to break through the dismal, epically deadly atmosphere in which we find ourselves today is to visualize. It starts with—apologies to Voltaire's Dr. Pangloss from *Candide*—the realization that we do not, in fact, live in the best of all possible worlds. But rather than mucking about in that bit of quicksand, all we have to do is find artists who visualize beyond the barriers of known problems and reveal what that better world not only looks like, but does. Artists like Jules Verne.

The world is in a state of constant change and the change is not as incremental as you might believe. The arts are important because they contextualize how that change manifests itself in your life, and also offer blue-sky, optimistic futures that paint the successful implementation of fundamental change. Just as

Verne did, an artist has the capability of not only predicting the future, but providing an enthusiastically positive road map of how to get there.

Dystopian futures are too easy to predict. They just take the negative issues of the present and devolve them to their natural conclusions. *Blade Runner. Snowpiercer. Logan's Run. Soylent Green. Mad Max.* Yawn.

Utopian futures are hard to come by.

So, is there a writer, a composer, a dancer, an acrobat, a standup comedian—an artist—who will eschew looking at the future with, at best, a glassy irony? Is there a nonprofit arts organization willing to create a regional or national vision of the ideal results of diverse, equitable, and inclusive leadership?

How about YOU?

Do you want to rehash how bad things are or do you want to create an ideal environment? Do you just want to fill the potholes of blight with your storytelling, or envision a bright new city? Would you rather "reopen" or "debut"?

Congratulations, You're Ready to Start

You wrote that anti-racist manifesto for your nonprofit. Great. What's more important, you're following it, even at the expense of your revenue streams or relationships. You actively hired leaders in all departments—not just a new DEI officer—from all parts of life: those over 50, those under 30, Black, Latinx, Indigenous, Asian American and Pacific Islander, Jewish, Muslim, etc. It's the right thing to do.

Progress.

You terminated key male personnel (and some women, too) because they violated the precepts of the #MeToo movement. Great. Whether you terminated the accuser because the accusation was bogus—retribution for some other slight—or you terminated the accused because the accusation revealed a

pattern of harassment, the result is material because you acted out of caution and knowledge that harassment is an issue, no matter what. It's the right thing to do.

Progress.

You jettisoned some toxic donors, board members, and patrons. Great. You recognized that when moral extortionists and sin sources keep your organization from doing what a nonprofit organization should—change your community for the better because you know there are deep faults in your community—they force you to drift your mission off-course and neglect your true stakeholders. Great. Your hands are clean and you can help all those people you had always intended to lift out of their social deficit. It's the right thing to do.

Progress.

Public opinion is on your side. And you've set up your organization so that they can help those underserved people who reside in your community.

Of course, the pendulum of public opinion depends on which public you're discussing. Or even if there is such a thing as a single "public." The problem with discussing any public as a unique entity is that the assumption is faulty, especially in the United States. This assumption leads to talking heads and thought leaders buffeting themselves against contradictory motivations, a prime tool to keep evolutionary change from happening.

> Voters are complicated. I think that that's something that we always forget. Voters will vote for increasing the mandatory minimum wage and they will also vote to support Donald Trump because, again, voters are people and people are complicated.
> —Jane Coaston, host of the *New York Times* podcast "The Argument"

Public opinion, however you define it, is meaningless for the nonprofit leader (board member, executive director, artistic director, that staff member that everyone listens to—you know the one). Public opinion is easy to come by, invent, and bastardize, and without question, the worst way to run a progressive, nonprofit organization.

But you've made progress. Great.

It's not enough. Sorry.

This time, your organization's (and your) future cannot and will not be determined by one-off acts of repair. Fixing the past is desperately necessary, to be sure. It continues to need to be done, no question. And sadly, there are too many among us who believe that none of it has to be done, just like the trillions of dollars' worth of deferred physical infrastructure repair in the United States.

Because of public opinion.

To realize a model future (instead of just a better future), we'll all have to alter Yogi Berra's famous quote to this:

> *If it ain't broke, break it. Then, for the love of Joe DiMaggio, don't just fix it. If it don't fit the perfect future, then fuhgeddaboudit. Build a new thing entirely.*

The model future will depend on our vision for it, not progressive mileposts leading to something predictable. In the same way that you cannot gauge success without a vision for it, nobody can create the perfect world without sculpting it.

> Sculpture is the simplest thing in the world. All you have to do is to take a big chunk of marble and a hammer and chisel, make up your mind what you are about to create, and chip off all the marble you don't want.
>
> —*The Index*, 1879

No, Michelangelo did not use this method, in case you were wondering.

Now you know why many nonprofit arts organizations, in the wake of all the issues that bombarded the sector (and the country) over the last several years, ought to, should, and will close down. They are like the rotted layer on the top of a moldy onion. The onion may still be good down deep, but that layer and those that touch it have got to go.

How will your nonprofit arts organization contribute to the newly sculpted vision that brings about the next era of building a better world? What is that vision—the ideal future, the next version of normal—that will lift the spirits of everyone and holistically, genuinely, better humankind?

I don't know. But I'm optimistic. It's coming, and soon.

How do I know that?

For the last 6 million years,
through 100 billion people existing over 300,000 generations
of greatness, horror, joy, sorrow, plagues, medical miracles,
destruction, construction, re-destruction, and re-construction,
humankind has created an earth that has always provided "the new thing,"
and the next generation
generates anew.
Every time.

I don't know about you, but I can't wait to see it happen again.

About Alan Harrison

Alan Harrison is and has been a father, writer, stage and film actor, nonprofit executive, cabaret piano player, composer, playwright, singer, columnist, critic, voice actor, association executive, and an arts-related board president (in no particular order). For the past 30 years, he has led, produced, directed, promoted, raised money for, succeeded and failed in over 300 theatrical productions on and off Broadway and at prestigious (and not-so-prestigious) nonprofit arts organizations across the United States. Among those organizations were Lincoln Center Theater, the Los Angeles Theatre Center, The Pasadena Playhouse, Pittsburgh Public Theater, Seattle Repertory Theatre, the Alabama Shakespeare Festival, and ArtsWest. He has a terrific son, Danny Harrison, and a partner in crime, Donna Oslin, who keep him in check…and stitches.

He's also a two-time *Jeopardy!* champion so, you know, there's that.

A Special Note to You, the Reader

Thank you for purchasing *Scene Change: Why Today's Nonprofit Arts Organizations Have to Stop Producing Art and Start Producing Impact*. My sincere hope is that you derived as much from reading this book as I have in creating it. If you have a few moments, please feel free to add your review of the book at your favorite online site for feedback. It helps to get the message out about the future of nonprofit arts organizations.

Also, if you would like to connect with other books that I have coming in the near future (*Scene Change for Boards* is tentatively the next title in this series), please visit my website for news on upcoming works, recent blog posts, and to sign up for my newsletter: **https://501c3.guru**. On the site, you'll find easy ways to contact me about the issues you might be facing within your own nonprofit arts organization. If you have noteworthy nonprofit arts organization stories—horror, glory, or funny—which you'd like me to share, I'd be delighted to chat.

Sincerely,

Alan Harrison

**CHANGEMAKERS
BOOKS**

Transform your life, transform *our* world. Changemakers
Books publishes books for people who seek to become positive,
powerful agents of change. These books inform, inspire, and
provide practical wisdom and skills to empower us to write
the next chapter of humanity's future.
www.changemakers-books.com

The Resilience Series

The Resilience Series is a collaborative effort by the authors
of Changemakers Books in response to the 2020 coronavirus
pandemic. Each concise volume offers expert advice and
practical exercises for mastering specific skills and abilities.
Our intention is that by strengthening your resilience,
you can better survive and even thrive in a time of crisis.
www.resiliencebooks.com

Adapt and Plan for the New Abnormal – in the COVID-19 Coronavirus Pandemic
Gleb Tsipursky

Aging with Vision, Hope and Courage in a Time of Crisis
John C. Robinson

Connecting with Nature in a Time of Crisis
Melanie Choukas-Bradley

Going Within in a Time of Crisis
P. T. Mistlberger

Grow Stronger in a Time of Crisis
Linda Ferguson

Handling Anxiety in a Time of Crisis
George Hoffman

Navigating Loss in a Time of Crisis
Jules De Vitto

The Life-Saving Skill of Story
Michelle Auerbach

Virtual Teams – Holding the Center When You Can't Meet Face-to-Face
Carlos Valdes-Dapena

Virtually Speaking – Communicating at a Distance
Tim Ward and Teresa Erickson

Current Bestsellers from Changemakers Books

Pro Truth
A Practical Plan for Putting Truth Back into Politics
Gleb Tsipursky and Tim Ward
How can we turn back the tide of post-truth politics, fake news, and misinformation that is damaging our democracy? In the lead-up to the 2020 US Presidential Election, *Pro Truth* provides the answers.

An Antidote to Violence
Evaluating the Evidence
Barry Spivack and Patricia Anne Saunders
It's widely accepted that Transcendental Meditation can create peace for the individual, but can it create peace in society as a whole? And if it can, what could possibly be the mechanism?

Finding Solace at Theodore Roosevelt Island
Melanie Choukas-Bradley
A woman seeks solace on an urban island paradise in Washington D.C. through 2016–17, and the shock of the Trump election.

the bottom
a theopoetic of the streets
Charles Lattimore Howard
An exploration of homelessness fusing theology, jazz-verse and intimate storytelling into a challenging, raw and beautiful tale.

The Soul of Activism
A Spirituality for Social Change
Shmuly Yanklowitz
A unique examination of the power of interfaith spirituality to fuel the fires of progressive activism.

Future Consciousness
The Path to Purposeful Evolution
Thomas Lombardo
An empowering evolutionary vision of wisdom and the human mind to guide us in creating a positive future.

Preparing for a World that Doesn't Exist – Yet
Rick Smyre and Neil Richardson
This book is about an emerging Second Enlightenment and the capacities you will need to achieve success in this new, fast-evolving world.